ICONS OF STYLE

Zendaya

First published in 2024 by Welbeck
An Imprint of HEADLINE PUBLISHING GROUP

1

Cataloguing in Publication Data is available from the British Library

ISBN 9781802798074

Printed and bound in China by Leo Paper

Headline's policy is to use papers that are natural, renewable and recyclable
products and made from wood grown in well-managed forests and other
controlled sources. The logging and manufacturing processes are expected
to conform to the environmental regulations of the country of origin.

HEADLINE PUBLISHING GROUP
An Hachette UK Company
Carmelite House
50 Victoria Embankment
London EC4Y 0DZ

www.headline.co.uk
www.hachette.co.uk

ICONS OF STYLE

Zendaya

The story of a fashion legend

Kristen Bateman

WELBECK

CHAPTER 3

Designers, Stylists and Major Moments

123

CHAPTER 4

The Next Generation of Style

173

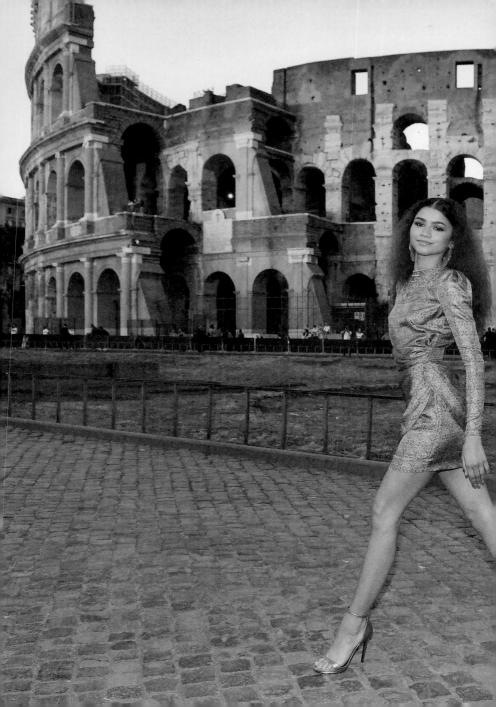

Introduction

Since the very beginning, Zendaya Maree Stoermer Coleman has been a shining style star. The American actress and singer has created her own unique aesthetic that not only defies stereotypes but creates its own visual language. From the famous red-carpet staircase of the Met Gala to her television appearances and movies across the globe, she doesn't just dress to fit a character, she transcends style and becomes the main character.

Managing the transition from child star to grown-up superstar, Zendaya has built her fashion reputation in a unique sort of way. From working with her famed stylist, Lawrence "Law" Roach, to collaborating with some of the top brands like Valentino and Louis Vuitton, she brings a serious résumé that goes far beyond the typical actress-singer who loves fashion.

Perhaps what's most interesting about Zendaya as a style muse is her penchant for risk-taking fashion. In recent years, she's never been one to play it safe, whether that means choosing a dramatic outfit which reflects one of her genre-defying characters, or opting for theatrics (like a light-up dress) on the Met Gala red carpet. "I've always loved fashion and I've found that it's an incredibly fun way

PREVIOUS Zendaya struts in front of the Roman Colosseum, wearing a gold dress in 2019 for a Fendi haute couture fashion show.

OPPOSITE Zendaya wears a luxe hand-embroidered piece by the designer Rahul Mishra.

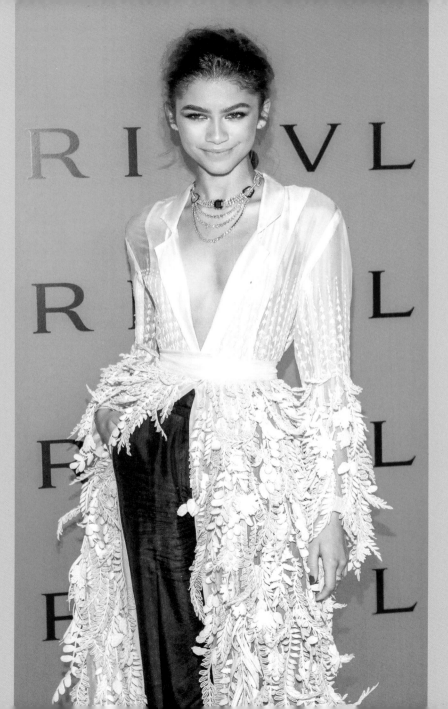

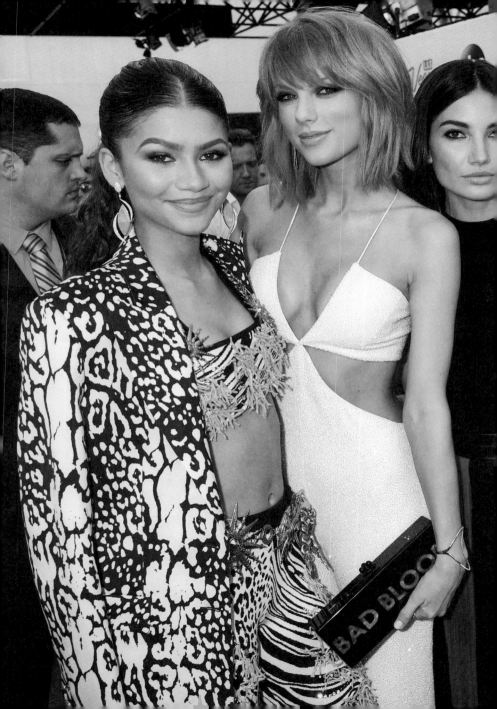

to express myself," she told *Harper's Bazaar UK*. "I definitely have a strong point of view on what I'm wearing and love to collaborate with my stylist, Law [Roach]."

With hundreds of millions of followers on social media, Zendaya holds a fan base and power that is an incredible force of nature. Cue her entering any fashion show, where thousands of people line up just for a chance to catch a glimpse of the legend and what she's wearing. The shouts and screams alone convey her epic influence.

Fandom aside, she is fiercely independent and opinionated on what she wears. Zendaya doesn't follow trends and often surprises on the red carpet and in her own personal style. Take, for instance, the time she wore a hot pink fuchsia Tom Ford breastplate. "Fashion has taught me so much about myself and how to be so much more fearless in a lot of different ways," Zendaya told *Vogue Italia*. "It has also helped me in other avenues of my life, whether it be business or even as an actress, to be more fearless and to not be so concerned with other people's point of view of what I look like or what I'm wearing."

Fashionable friends Zendaya and singer-songwriter Taylor Swift pose together for a photo.

"Fashion has taught me so much about myself and how to be so much more fearless in a lot of different ways."

ZENDAYA

Zendaya in a Marc Jacobs Spring 2019 dress straight from the runway.

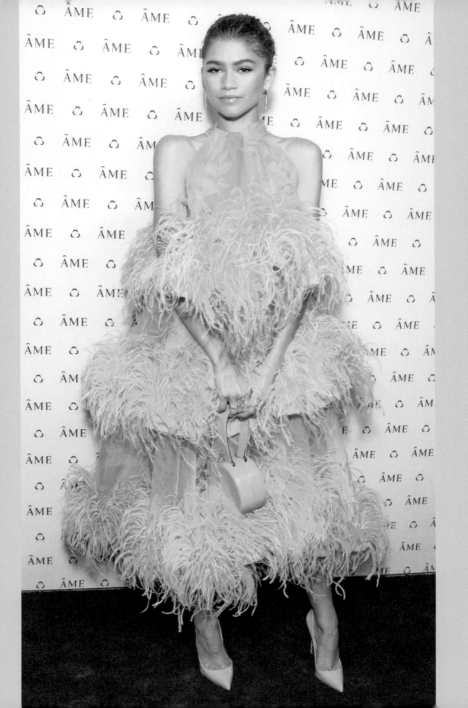

This book charts Zendaya's style ascension, from when she was a young Disney star to the increasing attention she garnered when she began working with her stylist, Law Roach, to her experience partnering with some of the top fashion brands in the world, not just as a fan but as an active collaborator. It covers some of her most stunning fashion transformations, from the runways to the premieres of her own movies.

Even if you're not familiar with the multitalented Zendaya, her endless skill for dressing and expressing herself through fashion has led her to pave the way as someone who is incredibly influential. Come on this visual and narrative journey to see why Zendaya is one of the most powerful style icons of our current times.

An early example of Zendaya's style at the 2014 MTV Movie & TV Awards.

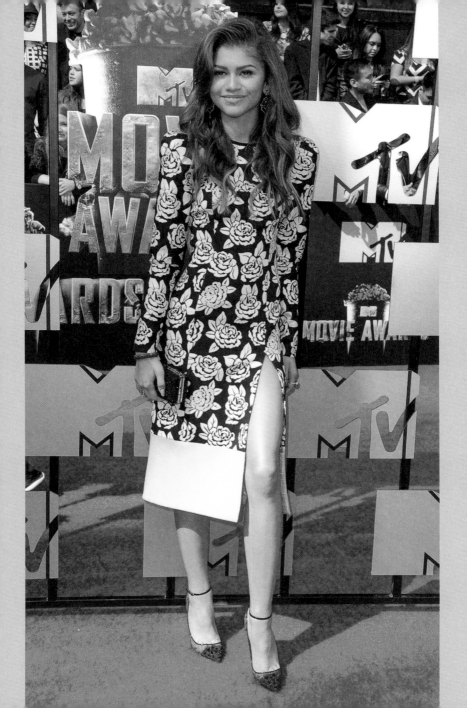

The Early

CHAPTER 1

Years

From her earliest days, Zendaya loved fashion. For a theatre kid, it made total sense. She was born on September 1, 1996, in Oakland, California and her parents, Claire Stoermer and Kazembe Ajamu Coleman, were both teachers. She began her career early, as a child model and backup dancer. At the age of six, she and two friends performed a play for Black History Month at Fruitvale Elementary School, where she was a student and where her mother was a teacher for two decades. Two years later, she joined the hip-hop dance group Future Shock Oakland, performing as a member for three years. As a performer, Zendaya has always had her hands in a variety of different projects. She danced hula with the Academy of Hawaiian Arts and also performed at her local Shakespeare Theater in Orinda, California. Once she started attending Oakland School for the Arts, she was cast in even more local theatre shows, playing roles in various productions.

Bella Thorne with her *Shake It Up* TV series co-star Zendaya in 2010.

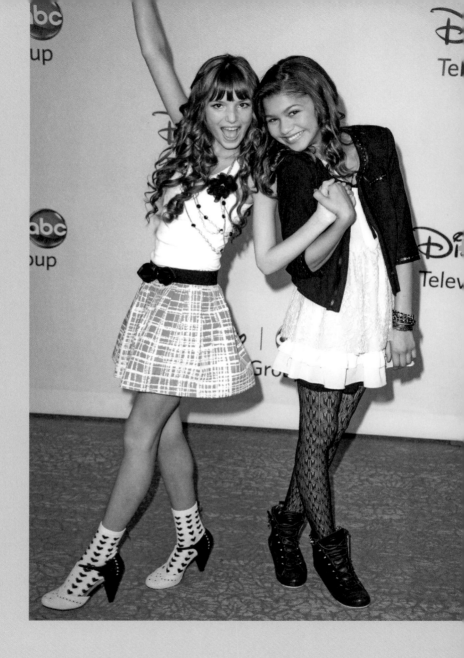

At this time, Zendaya was also already playing the role of fashion expressionist. For example, she loved clothing covered in rhinestones and already had a knack for dressing in fun vintage pieces. After all, she grew up with two glamorous grandmothers, each of whom loved fashion. She would borrow their slip dresses and fancy costume jewellery from the backs of their closets, dressing up and posing for photos. And while Zendaya's mother may have been a teacher, she also had a love of fashion for her own very different reasons. Often her clothes were tailor-made since she stood tall at 6'4" and couldn't find what she wanted to wear in her size. Zendaya, who now stands at 5'10", was soon able to relate to this. "She was always made to feel like she couldn't enjoy certain fashions because they literally didn't make them for her or because people always made comments about her height, and she was self-conscious about it," Zendaya told *Elle*. "I also felt like there was part of her that loved fashion. But it was hidden. I think she vicariously lived through me experimenting."

Zendaya pictured with her family. The star has often credited her mother and grandmother with influencing her love of fashion.

Zendaya's family moved to Los Angeles when she was in 7th grade, which kicked off her career and also allowed her to become even more experimental with her sense of fashion. Working as a model for American commercial retailers including Macy's, Sears and Old Navy, she began getting cast in national ads alongside Disney stars like Selena Gomez. And in 2009, she was cast as Rocky Blue in the Disney sitcom, *Shake It Up*. Zendaya was catapulted into stardom on November 7, 2010 when the show became Disney Channel's second highest-rated premiere in the TV channel's 27-year history with 6.2 million views. In 2012, she also played a role in *Frenemies*, a Disney Channel Original Movie.

OPPOSITE An early example of Zendaya mixing and matching her girly aesthetic with more edgy elements.

OVERLEAF Zendaya and Bella Thorne's outfits on *Shake It Up* represented each character's own personal style.

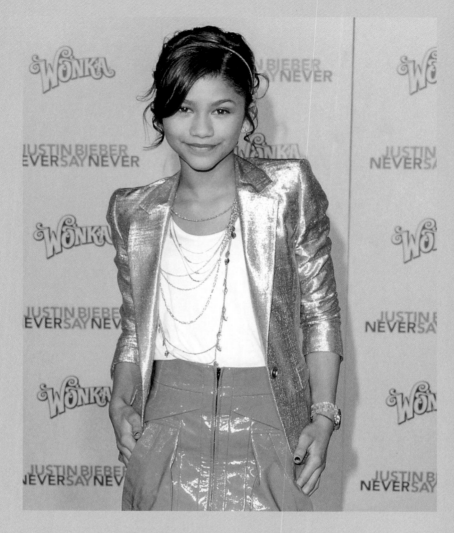

ABOVE Zendaya often wore metallics during her *Shake It Up* era, both on screen and on the red carpet.

OVERLEAF When Zendaya was still shaping her own personal style, she often mixed in ultra-casual pieces like sweatshirts with gold jewellery.

Shaking it up

Shake It Up actually helped cement Zendaya's fashion status early on. The show was all about two young girls (Zendaya starred opposite Bella Thorne), whose dreams of becoming professional dancers are realized when they land roles on a popular teen dance show. In 2011, the show had reached such great heights of popularity that Disney released a fashion collaboration inspired by the series which was available at the American retail giant Target.

Inspired by Rocky Blue/Zendaya's and CeCe Jones/Bella Thorne's sense of fashion, the tween fashion line was dubbed "D-Signed". And rather than the typical Disney merch this line was different. The collection was inspired by the characters' personal style and the items you would find in their closets.

In *Shake It Up*, Rocky often wore tutus over printed leggings, polka-dot prints and metallic belted dresses, with plenty of fun vests, hats and tie-dye prints. The *Shake It Up* fashion collab featured some of the same motifs, as well as sequins, grommets and stud accents, animal prints and of course, tie-dye.

Around this time, Zendaya began making appearances on the star-studded red carpet as a regular occurrence. As a young teenager, she was wearing regular, approachable brands rather than designer labels. "When I was 14 and at my first movie premiere, my outfit was a bunch of stuff that I had from Target," she told *InStyle*. "And I thought I was fly. I felt cool. To this day, I think that's really all that matters. Then you know you're doing the right thing."

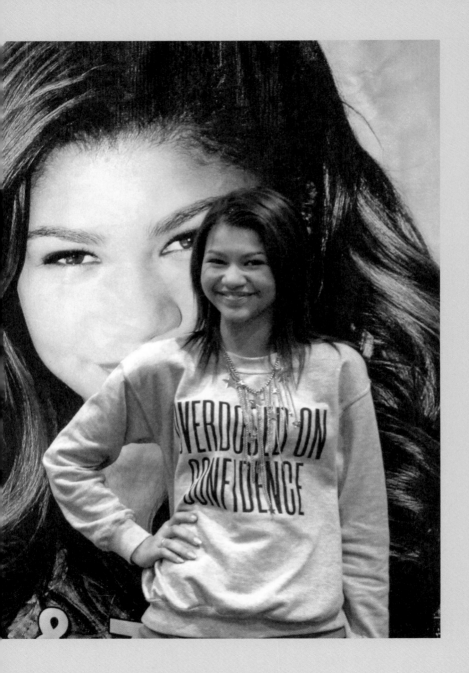

When Zendaya met Law

Back in 2012, Zendaya had already started working with the stylist Law Roach. Even so, she was still finding her fashion footing. In 2023, she said that the worst outfit she ever wore was during the press tour for *Shake It Up* in 2012, in Germany. Law Roach styled her in a striped cardigan, a blue blazer and a yellow T-shirt. It was one of the first times the two had worked together. "When she was 14, she didn't know much about fashion, and we were starting to learn about each other. And I think I had a little bit more say-so in the look," Law Roach told *Women's Wear Daily*.

Zendaya met Law Roach through a family friend when she was 14. At the time, he was running his Chicago boutique, Deliciously Vintage. He was also working as a personal shopper for a family friend of Zendaya's and she asked him to help style her for an event – specifically Justin Bieber's *Never Say Never* concert film premiere. He styled her in a metallic blazer and miniskirt look.

Still, Zendaya was interested in expanding her fashion vocabulary and finding her own personal voice through style. In 2012, not long after her first red carpet, when she was in Paris for her show, *Shake It Up*, she bought what she considers her first fashion investment: a Louis Vuitton bag. Little did she know she would eventually end up working as a fashion ambassador to the brand later in her life.

One of Zendaya's first true forays into fashion was a footwear collab – and her love for shoes showed through some of the more interesting heels she wore.

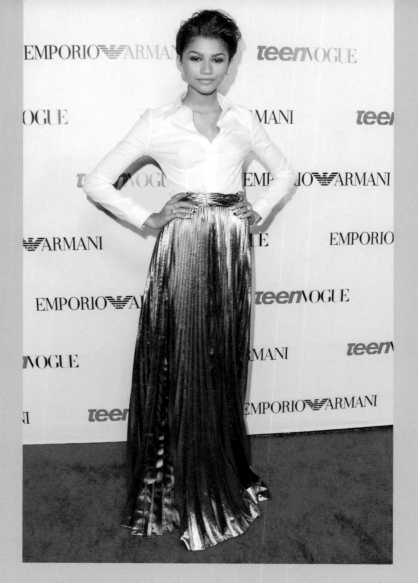

ABOVE Zendaya is a master at mixing casual and formal, as seen here, with a white button-down and gold metallic skirt.

OPPOSITE Zendaya proved early on that she loves contrast – like a white tulle dress with a toughened-up black leather biker-inspired vest.

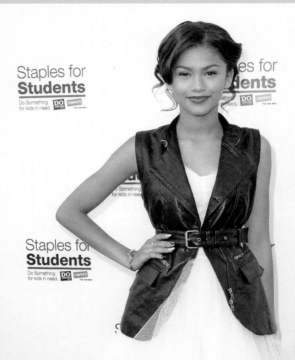

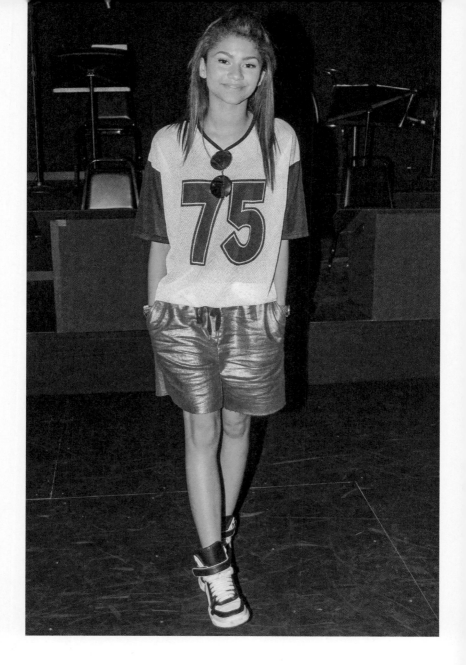

Throughout the next year, Zendaya refined her style with Law Roach to make it feel truer to herself. There were several different outfits that felt more expressive and edgy than what she was wearing in the past. Take, for instance, in 2012 when she wore a black leather vest over a white tulle dress with metallic fuchsia heels (see previous page). It was the start of the star's experimentation of mixing masculine elements with feminine notes.

In 2013, she began getting a little bit more playful and feminine, opting for floral skirts paired with sweaters with rhinestone collars, strappy heels and statement accessories like silky hot pink clutches and eccentric eyeglasses. She was still young and her fashion choices reflected that – always age-appropriate but fashionable. Off the carpet, she started getting a little bit more expressive with her style, too. Now she gravitated toward sporty options like metallic shorts and sports jerseys paired with high-tops. Elsewhere, on the red carpets, she began going in a more grown-up direction, wearing long white off-the-shoulder dresses. To couple this newfound style, she was making major headway in her career too. The same year, Zendaya's self-titled debut album was released, she was cast as 16-year-old Zoey Stevens, the lead character in the Disney Channel Original Movie, *Zapped* (2014), and she was also cast as the lead in a Disney Channel pilot, *Super Awesome Katy*, which would later be called *K.C. Undercover*.

At the heart of Zendaya's early sense of personal style is an inherent mix of casual, sporty staples.

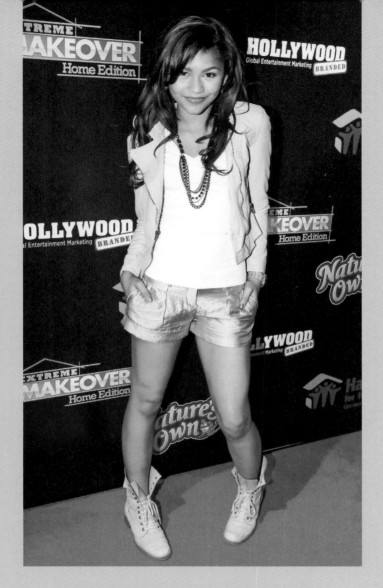

ABOVE Zendaya's penchant for suiting went one step further with these mini silver shorts and grey blazer.

OPPOSITE Sleek, minimalist or maximalist, Zendaya transforms effortlessly to any style, always with an eye on bold accessories.

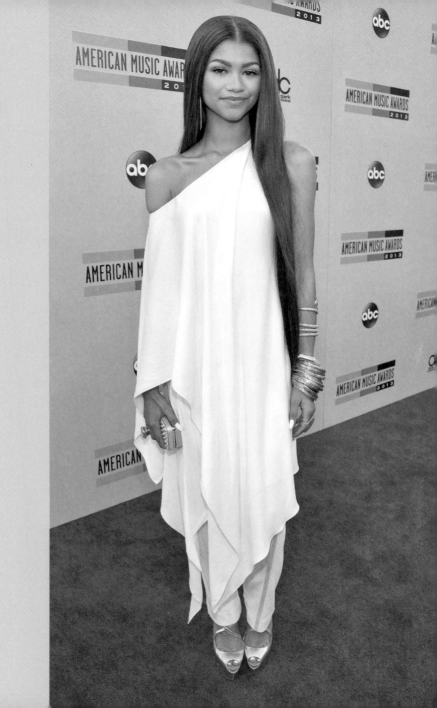

Style on screen

In *K.C. Undercover* (2015), Zendaya got a chance to play with her fashion on screen in a very different way. K.C. Cooper is essentially a teenage genius who discovers that her parents are actually spies, working for a secret agency called The Organization. K.C. (Zendaya) is then recruited to help because of her math and computer skills, going on top secret missions. Of course, in these missions, she has to dress up in disguise.

Throughout the show, she changed her look to be everything from a gothic punk (complete with spiked wig), to full-scale ballerina. With a little help from prosthetics, she even transformed into an old man janitor and a young cadet boy. The show used extreme special effects make-up to take Zendaya from retirement home to secretary office, often to great comedic effect. With Zendaya being known for a low-key make-up and beauty look in real life, it made the show all the more interesting. When she was an off-duty teen on the show, she mainly wore teenage appropriate T-shirts and jeans from approachable brands like Topshop. In these moments, her look on screen closely mirrored her look in real life – when she wasn't on the red carpet, that is.

OPPOSITE Even as she continues to develop her style on the red carpet, Zendaya loves to keep it comfortable while off duty.

OVERLEAF In her role on the sitcom *K.C. Undercover*, Zendaya went undercover to play various characters – allowing her to try every style under the sun, including prosthetics.

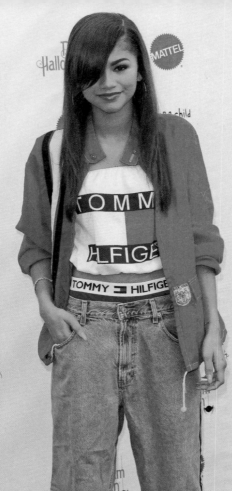

In the July 2017 issue of *Vogue*, the actress revealed in her cover story that she wouldn't sign onto *K.C. Undercover* without Disney meeting her demands for the show. These included making her a character who wasn't just a singer and dancer. "I want her to be martial arts-trained. I want her to be able to do everything that a guy can do," she explained. "I want her to be just as smart as everybody else. I want her to be a brainiac. I want her to be able to think on her feet. But I also want her to be socially awkward, not a cool kid. I want her to be normal with an extraordinary life." At just 16 at the time, she also asked that her character's name be changed from Katy to K.C., that a family of colour appeared in the show and she also rightly asked to be made a producer on the show. She of course won.

Tommy Hilfiger was one of the very first fashion brands to bring Zendaya on as an ambassador and collaborator in spring 2019.

By the time 2014 came around, she was pushing her experimentation with fashion to a new level. And people were starting to recognize it, too. It was clear that Zendaya was having fun trying on different characters. One night she would wear a slick black suit paired with a massive, sculptural hat to match. The hat moment was one of the times Zendaya started to really feel like she was pushing away at the typical conventional red-carpet fashion seen everywhere. "People were like, 'Oh no, Zendaya's gonna start looking like this now,'" she remembered, during an interview with *Elle*. Another evening, she opted for a structured short suit with Bermuda shorts, a crop top and heels. For a different event, she chose a yellow floral dress. She was not afraid to play with her hair and make-up either, seamlessly switching it up between long, glam waves, structured bobs with bangs, Afros and natural texture. In one instance, she stunned in a grey and black floral Dior gown. The same year, for the first time, she starred as a guest judge on an episode of *Project Runway: Under the Gunn*. The challenge? Contestant designers had to create an outfit for Zendaya to wear to an upcoming concert performance.

One of Zendaya's first high-fashion, experimental outfits was seen at *Teen Vogue*'s 12th Annual Young Hollywood issue launch party on September 26, 2014.

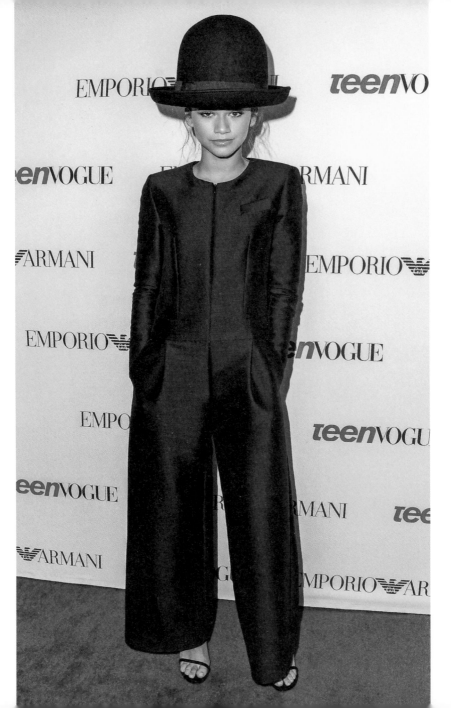

"I definitely have a strong point of view on what I'm wearing."

ZENDAYA

Zendaya was the ultimate punk princess in Vivienne Westwood
at the 2014 Princess Grace Awards Gala.

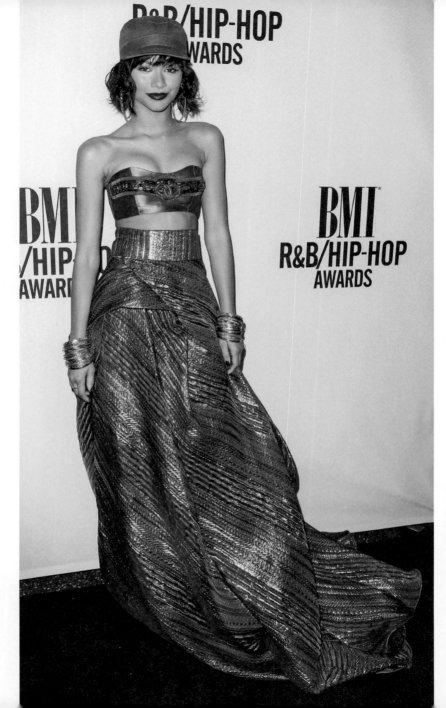

OPPOSITE Zendaya loves metallics and often integrates them into her outfits, as seen here at the 2014 BMI R&B/Hip-Hop Awards.

ABOVE When Zendaya does experiment with colour, she favours bold combinations like baby pink with lime green.

Zendaya's red-carpet reveal

During this time, Zendaya had begun to wear high-end designer clothing for her red-carpet appearances. Though she was still considered to be at the beginning of her career, Law Roach had found a way to dress her in some of the most extravagantly fitting fashion of the time – with a unique strategy behind it too. "Nobody wanted to dress her when she wasn't known, so I would put her in things that other people had already worn," he told the *Guardian*. Those repeat outfits attracted the attention of tabloid "Who Wore It Better" columns which drummed up interest and excitement for the star's style. "You've got to be a strong girl to do that on the red carpet. You have to have conviction to say, 'I like this, and I think I look cool, and f—k you to everybody who doesn't,'" he explained. "I think all my girls have an element of 'f—k you' in them."

An expert at red carpet style, Zendaya often opts for gowns or suiting with iconic structures and strong shapes.

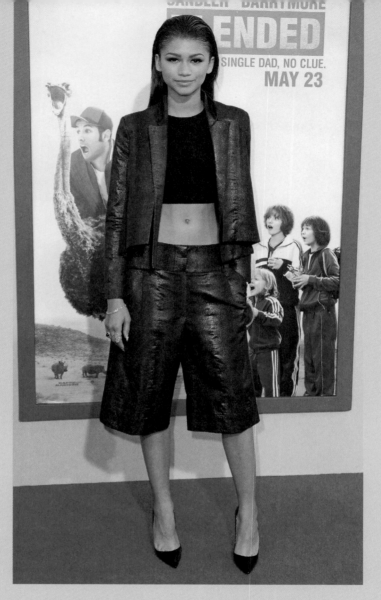

ABOVE Effortlessly playing with proportions at the *Blended* film premiere in 2014.

OPPOSITE While Zendaya goes all out with the glamour on the red carpet, she also knows how to dress perfectly casual in her own way.

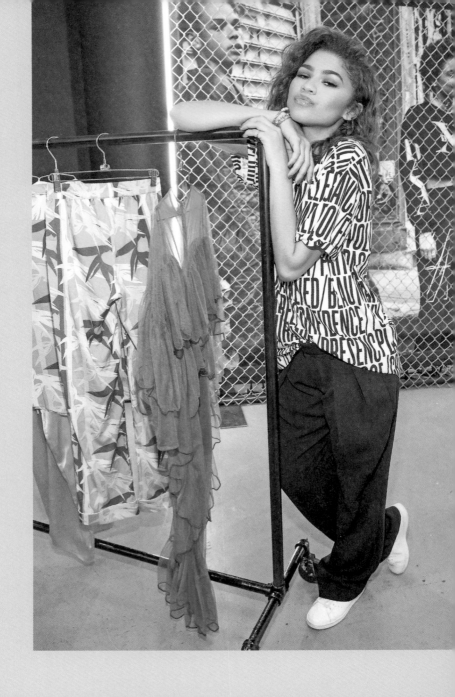

"I used to be very afraid until Law got into my life."

"He pushes me to try new things, I push him to try new things, and **we inspire each other** as we go along."

ZENDAYA

OVERLEAF Zendaya in a deep scarlet red Marchesa gown at the 2016 Golden Globes.

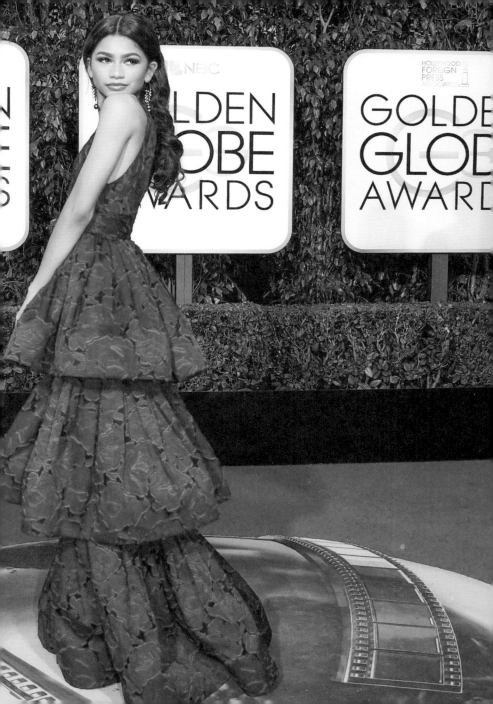

By 2015, it finally felt like Zendaya was coming into her own as the style icon she is today. She had just turned 18 and was constantly in the limelight for the way she dressed. This was true for a few different reasons. For one, she created her very first fashion product – a shoe collection. Dubbed "Daya" (inspired by her childhood nickname), the project was a collaboration between the 18-year-old star and her stylist, Law Roach. Ranging in price between $125 and $175, the shoes were inspired by the styles Zendaya was wearing on the red carpet. "The kind of women we're targeting are real women [who] want a good shoe they can wear to their job interviews, but [can] still be stylish and not break the bank," she told *People* at the time. "But it's not like that typical look for less. No, these are dope shoes and you don't have to spend three years trying to buy them."

Zendaya showing her love for fun footwear in a casual outfit paired with some fluffy sandals.

OPPOSITE Structured leather jackets and blazers are a
key item of Zendaya's personal style.

ABOVE Zendaya never shies away from prints, as seen here.

"Clothes start to perish but jewellery, my friend ... it's true what they say – diamonds are forever"

ZENDAYA

While Zendaya loves wearing ultra-glam gowns on the red carpet, she also wears suits and two-piece sets that show she's unafraid of doing things differently.

At the time, Zendaya described her own sense of fashion as "fearless". She told *StyleCaster*, "I used to be very afraid until Law got into my life. He pushes me to try new things, I push him to try new things, and we inspire each other as we go along. Everything kind of happens very organically and yeah, I would say [I am] fearless." She also named Madonna and Erykah Badu as two of her style icons that she looked up to during that time. And she cemented her love of fine jewellery early on, too, telling the publication she'd buy "lots of diamonds! Jewellery, because that'll last forever. Clothes start to perish but jewellery, my friend ... it's true what they say – diamonds are forever," when asked what she'd buy if she won the lottery tomorrow.

OPPOSITE Jewellery is a great part of Zendaya's look – and she loves big, bold pieces.

OVERLEAF Pearls, diamonds and gemstones are the fashion items Zendaya chooses to invest in personally.

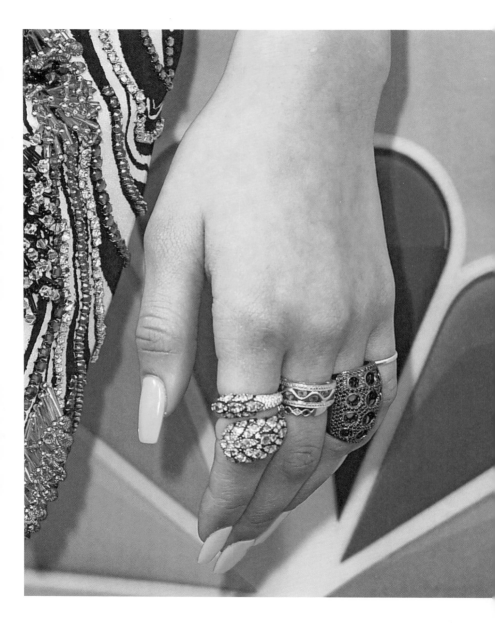

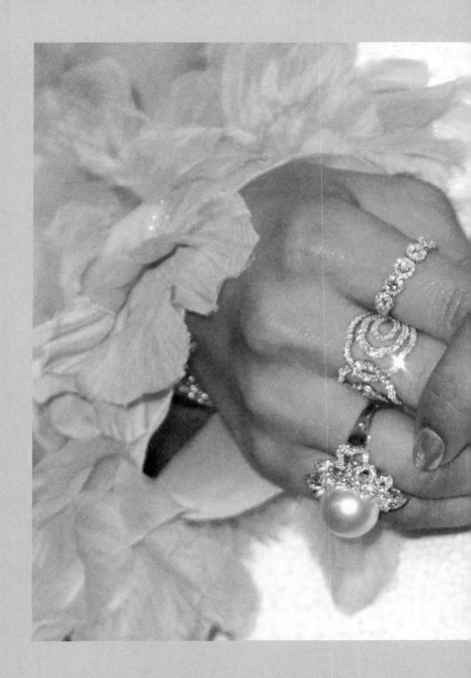

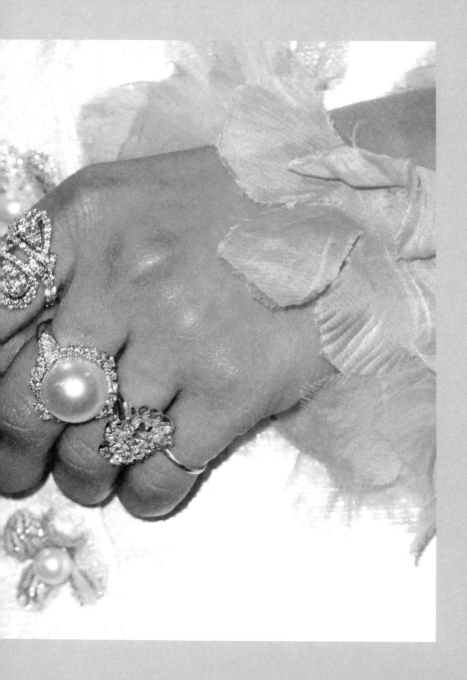

But perhaps it was one of Zendaya's 2015 outfits that made the biggest impact of all. Wearing a Vivienne Westwood white gown that made her look like a Grecian goddess, she chose to wear her hair in a cascade of locks to the Academy Awards. And though she had her own prolific following associated with her fan base, she was still considered relatively new to the A-list Hollywood scene. Not long after she walked down the red carpet, Giuliana Rancic, an *E! News* anchor, made her infamous comment: "I feel like she smells like patchouli oil," she said. "And weed." But Zendaya wasn't going to back down and was quick to respond on Instagram with, "There is already a harsh criticism of African-American hair in society without the help of ignorant people who choose to judge others based on the curl of their hair." And just like that, she was rightly praised for making a dramatic style statement and for using her platform to make a positive change and stand up for herself. Mattel even created a Zendaya Barbie doll, wearing the same dress and hairstyle as Zendaya wore during the evening. "That's how change happens," Zendaya told *W* magazine in 2021, when she was asked to remember the event. "And it made me think, How could I always have a lasting impact on what people saw and associated with people of colour?" The same year, she graduated from Oak Park High School.

At the 2015 Academy Awards, Zendaya stunned everyone with her white Vivienne Westwood gown.

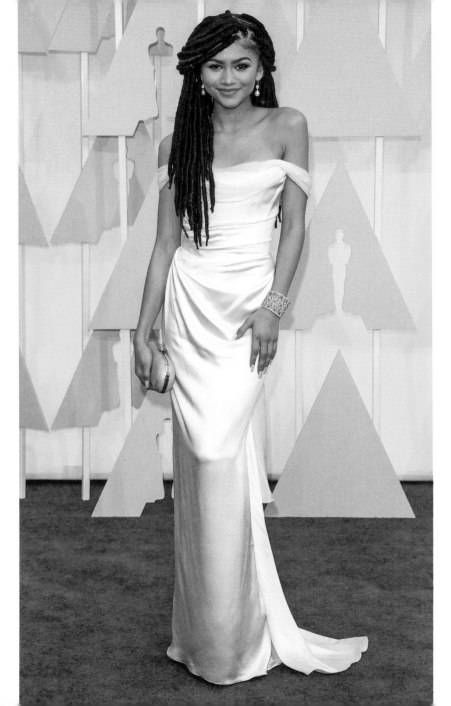

Throughout her career, Zendaya has always been vocal about her own hair. In an interview with *New York* magazine, she explained how when she was younger, she went through a phase when she didn't like her hair and how she grew up going to a school that was primarily Caucasian and where there was no one who had her hair texture. "I didn't quite respect and love what I had, hair-wise. It took me a while to appreciate the hair that I have and find it beautiful," she explained. "When I deal with my little nieces, I'm like, 'Don't you touch your hair.' It's really cool now seeing a movement of women of color embracing their natural hair, posting about it, having blogs about it, and really showing it as beautiful. Women need to see that at a young age and connect and identify with it, so that they can feel that what they have is good enough."

Of course, her loyal stylist Law Roach played a big role in styling Zendaya for her Vivienne Westwood moment, too. More than ever, it solidified the partnership of the two's creative endeavours – till this very day. "He's involved in every fashion contract, everything I do," she told *Elle* in 2023. "If I have an opportunity where he can come with me, he's always going to be there. He's always been my creative director in a sense, and he continues to fill that role, because it's more than just clothes on a red carpet. It's a bigger thing."

No stranger to switching up her hair and make-up for a big event, Zendaya seamlessly shapeshifts through different looks.

Not long after, Zendaya would continue pushing the boundaries of risk-taking fashion with another extremely memorable look that was equally unexpected. It was the 2016 Grammy Awards and the singer-actress had just released her new single, 'Something New'. On the red carpet, she decided to channel one of music's most inspiring style icons: David Bowie. Just like Bowie in his early years, she decided to play with gender roles by wearing a masculine wide-leg, black double-breasted Dsquared2 suit with a structured white button-down shirt. She stacked her fingers full of glittering rings and her hair was styled in a dramatic honey-coloured mullet – a big switch-up for the starlet. *Vogue* called it her "biggest risk to date." Remembering the look years later, she told *InStyle*, "I got dragged for my mullet at the time, but kids love mullets now. I'm happy about my David Bowie mullet."

It was this, and the Vivienne Westwood moment, combined with Zendaya's newly cemented record of powerful fashion moments – and her outspoken personality and fan base – that would later lead to boundless opportunities in fashion. No longer was she just a singer-actress, she had totally ascended to style icon.

At the 2016 Grammy Awards, Zendaya took a page from the David Bowie playbook with inspiration from the classic style icon's androgynous style and mullet hair.

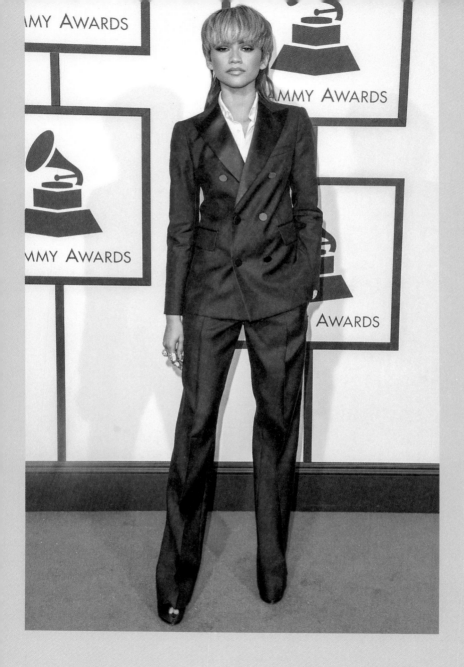

"*It took me a while to appreciate the hair that I have and find it beautiful.*"

"*I got dragged for my mullet at the time, but* **kids love mullets now**"

ZENDAYA

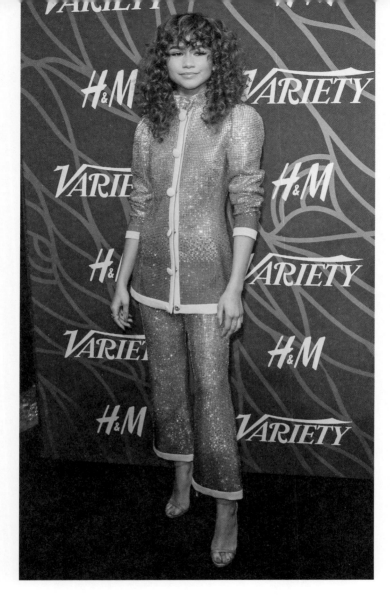

ABOVE Pretty in pink in a glittering set by Vivetta.

OPPOSITE At Paris Fashion Week in 2016, Zendaya
mixed and matched prints by Kenzo.

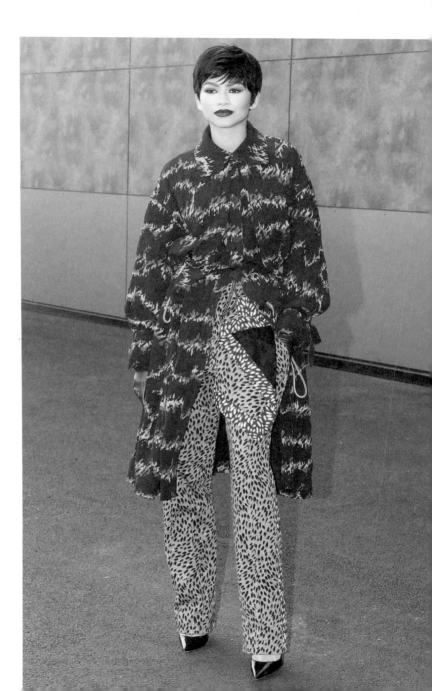

A Style Star

CHAPTER 2

is Born

In 2016, Zendaya showed the world she was serious about fashion. She expanded on her fashion knowledge and experience by turning Daya into a fully fledged fashion line that went far beyond shoes.

With an emphasis on all things androgynous and gender fluid, the collection included a range of clothing for under $160. Most importantly, the collection was size inclusive, up to a size US 22. In 2016, this was truly groundbreaking. "That just seems like a no-brainer to me," she told *Elle* at the time. "Why would I alienate an entire group of people and make them feel like they can't access my clothes?" The range included everything from forest green velour tracksuits to satin-y slip dresses with matching robes. "That was my thing – I'm not going to make clothes my sister or my niece or any of the women in my family can't wear," she told *Allure*. "A lot of the clothes were for tall people too. For my mom, this is the first time that she can wear pants and not get them altered – she's six feet four."

Once Zendaya became more in tune with her own personal style, she started experimenting more and more, as seen with this Vivetta horse gown that she wore to the Fashion Awards 2017.

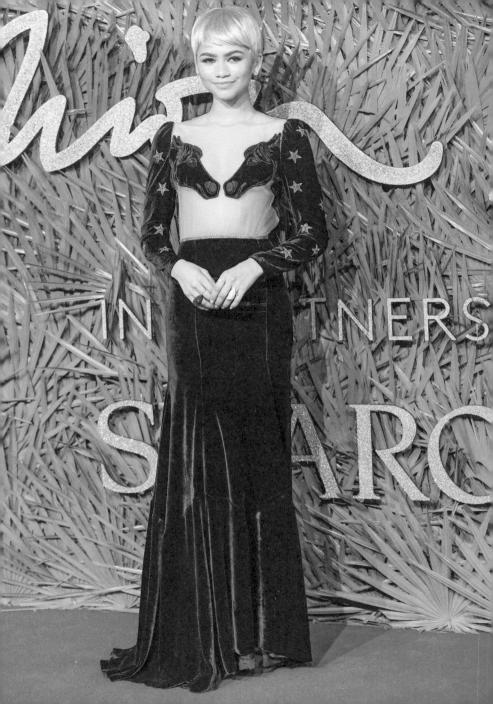

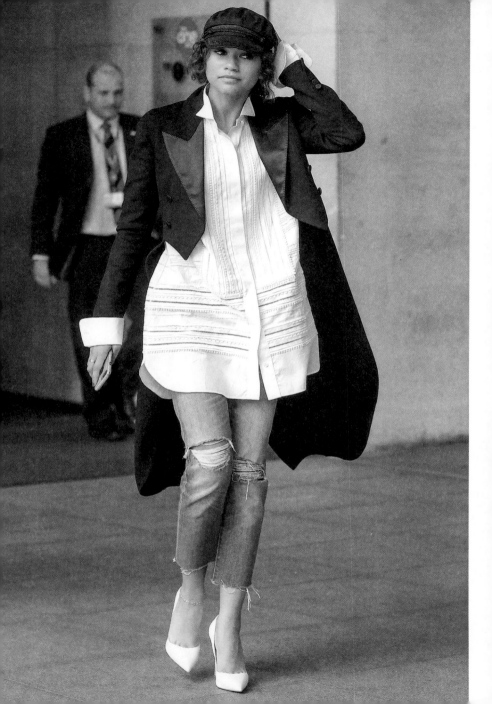

For the occasion, Zendaya was also inspired by bending fashion's perceived rules. She has often said that she doesn't believe that a label on a shirt or a dress should tell her that she can't wear a T-shirt or a pants because it should say "women's" or "men's", for example. "I think that I get to represent different types of beauty that [are] not just my own. I get to represent a lot of different types of women because of my ability to transform into these different people," she added. "I think a lot of women can see themselves in me and a lot of people in general are empowered by seeing someone wear what they want, do what they want, maybe get criticism or get praise, whatever, but still continue to wear and do what they want. I think that a lot of people need that."

Even though Zendaya's glammed-up red carpet outfits persisted, she continued to mix casual with more formal tomboyish staples for her everyday looks.

Getting into character

The year 2017 set a new bar for Zendaya and her fashion choices. She scored her first ever *Vogue* cover and was now internationally recognized for her highly personal style that was statement-making and unique. She was also starring in bigger productions, bringing her a larger fan base along for the ride and allowing her even more opportunities to show off her predilection for high fashion. First up? *Spider-Man: Homecoming* and *The Greatest Showman*, both premiering in 2017. For each of these occasions, the general public got to see Zendaya dress in a way that conveyed her character on the red carpet.

OPPOSITE Zendaya loves a dramatic fashion piece – like a blue tutu, by London-based designer Molly Goddard.

OVERLEAF For her role as Anne Wheeler in the musical-drama *The Greatest Showman* (2017), Zendaya was transformed with a pale pink wig.

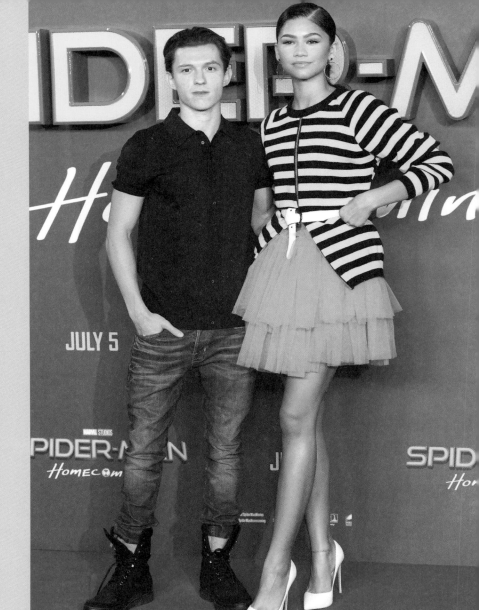

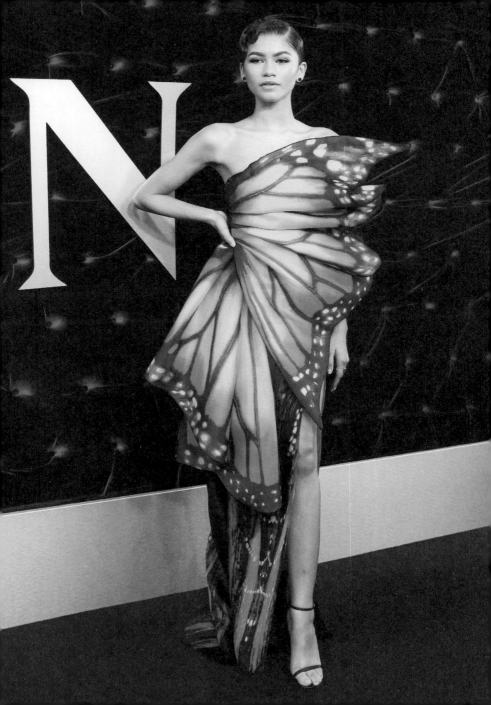

For example, while on tour to promote her film, *The Greatest Showman*, alongside Hugh Jackman and Zac Efron, she sported a stunning red and orange gown that resembled a butterfly's wing, designed by Jeremy Scott for Moschino. Interestingly enough, *The Greatest Showman* was based on the life story of P.T. Barnum, the man behind the Barnum & Bailey Circus. Zendaya played the role of Anne Wheeler, one of the main acts in the circus. Wheeler was a tightrope walker who wore a pink wig and purple costume when performing. Almost as if Zendaya was inspired by her circus performer character, she dressed in very fun, eccentric outfits. And lots of them. At the time when she was on tour to promote the film, she was once spotted wearing six different outfits during a single day in New York City.

On the red carpet, she was gaining more and more confidence, becoming fearless with her choices. Nothing was off limits and yet everything she chose was shrouded in elegance and glamour – never costume-y, despite playing the role of a circus performer. She has worn glittering ombre pink and red pants and a matching button-down, and a black velvet maxi gown with a sheer torso area and horse-shaped velvet patterns covering her bust. Both were designed by Vivetta, the Italian contemporary brand founded by Vivetta Ponti.

Some of Zendaya's most extreme outfits have been designed by Jeremy Scott, such as this Moschino butterfly dress.

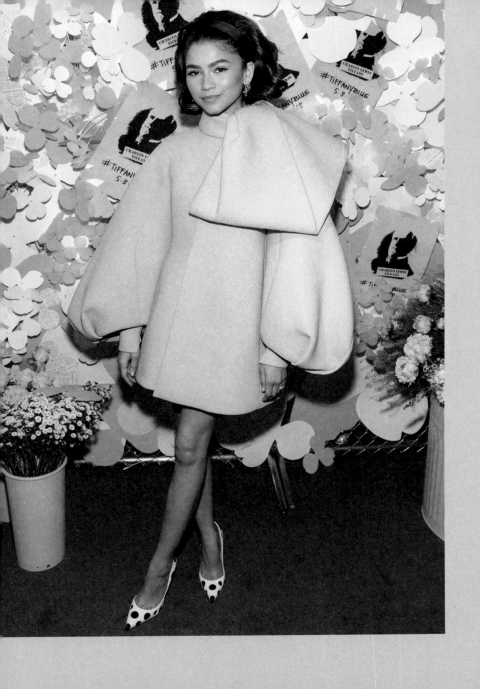

"*I think a lot of women can see themselves in me and a lot of people in general are empowered by seeing someone wear what they want, do what they want, maybe get criticism or get praise, whatever, but still continue to wear and do what they want. I think that a lot of people need that.*"

ZENDAYA

Zendaya's style is effortlessly playful – like when she wore
a powder blue dress to a Tiffany event.

When it came to *Spider-Man: Homecoming*, Zendaya played the role of Michelle, who as the viewer learns toward the end of the film, ends up being M.J. Michelle, a brooding genius-type rooted in intellect. And though the character has a very small role (she'll make a major appearance in the *Spider-Man* universe later on), she proves she's nothing like the damsel in distress type of female characters we've seen in previous iterations of *Spider-Man*.

Likewise, while on tour to promote *Spider-Man: Homecoming*, Zendaya strategically dressed to do the opposite of blending in. She began with a bang, in a neon pink Ralph & Russo gown, Casadei heels and Bulgari jewels at the film's L.A. premiere. Then in New York, she opted for a striped red and white dress with a chunky silver belt. The rest of her outfits for the promotional tour mixed in her now signature silhouettes (suits, for instance) with wild details. She wore a pinstripe Seen Users suit covered in red roses, a turquoise Molly Goddard tutu paired with a yellow and black striped cardigan and a soft Sies Marjan draped dress in the palest shade of green.

OPPOSITE Zendaya attended the world premiere of *Spider-Man: No Way Home* in 2021, wearing a custom Valentino dress embellished with surreal black spider webs.

OVERLEAF Zendaya's role in the movie *Spider-Man: No Way Home* may have been small, but her fashion influence during this time was significant.

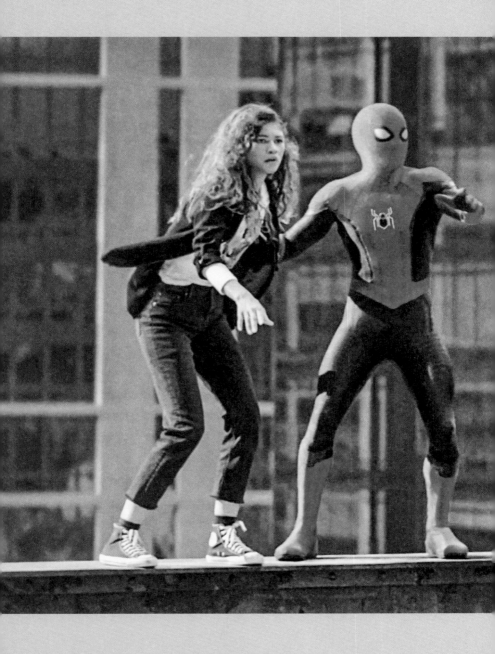

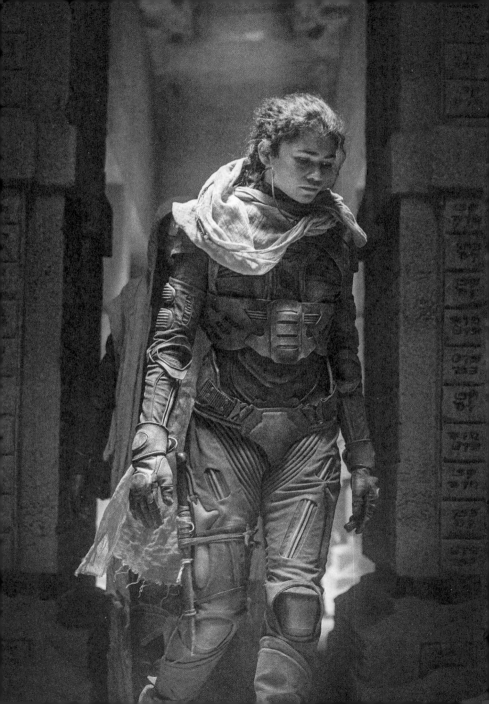

Perhaps her greatest mastery of playing the main character on the red carpet came when she was on tour to promote *Dune* (2021). Call it method dressing, but the star not only embodied her character, she also played subtly with the storylines and mixed it in with her wardrobe. While on the press tour to promote the film, she wore Vivienne Westwood, Alaïa, Haider Ackermann, Balmain, Valentino and other legendary designers. Presented in two parts, *Dune* is an American sci-fi movie directed by Denis Villeneuve. It serves as an adaptation of the 1965 novel of the same name by Frank Herbert. *Dune* is set in a distant future, following Paul Atreides as his family, the House Atreides, go to war on the desert planet, Arrakis. In the first *Dune* movie, Zendaya stars as a Fremen named Chani, who haunts the dreams of Paul Atreides (Timothée Chalamet). Despite heavily featuring Zendaya in the marketing of the first film, she mainly appears in short sequences in Paul's dreams, but later serves as a bigger part of the sequel, *Dune 2*.

OPPOSITE In *Dune* (2021), Zendaya played Chani and wore futuristic, apocalyptic styles that mirrored her red carpet choices at the time.

OVERLEAF Zendaya's new look in *Dune* served as the theme for all her red carpet looks during the time that she was promoting the film.

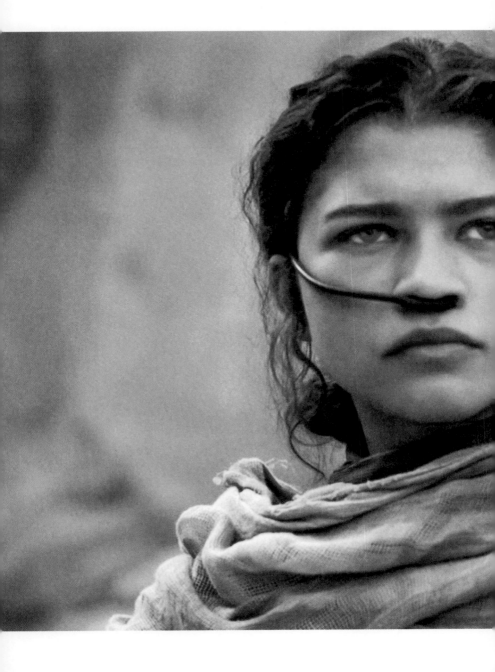

Dune allowed Zendaya to tap into expressing herself with fashion like never before. It was the first time that fans could see her wearing some of the most distinctly edgy, futuristic looks in fashion. When she wore the chain-mail-embellished top and chequered skirt designed by Andreas Kronthaler for Vivienne Westwood (straight from the label's spring 2020 collection), she made a style statement all of her own. It seamlessly nodded to the futuristic aesthetic of *Dune*, albeit in a highly fashion-forward, wearable way. This was also a very smart move to link her red-carpet fashion appearances to her character and she did so in a way that didn't feel like she was wearing costumes. According to the Vivienne Westwood brand, Zendaya's outfit also had an element of sustainability, aligning with the star's history of using her platform to elevate fashion that does good. The skirt was hand-painted with natural dye from Burkina Faso and created in collaboration with the Ethical Fashion Initiative (part of the International Trade Centre – it serves as joint body of the United Nations and the World Trade Organization – which currently supports the work of thousands of artisan micro-producers from marginalized African communities).

For *Dune*'s London premiere, Zendaya wore an asymmetrical Rick Owens dress, later changing into a cut-out, lingerie-inspired dress by emerging designer Nensi Dojaka for the after-party. Honing in on a neutral colour palette with strong lines and architectural silhouettes meant that many of Zendaya's looks for her *Dune* press opportunities had that post-apocalyptic feel. Rick Owens, in particular, is a designer

Zendaya tapped into a new side of her personal style for the first time during her *Dune* era – one that felt darker, more minimal and more futuristic.

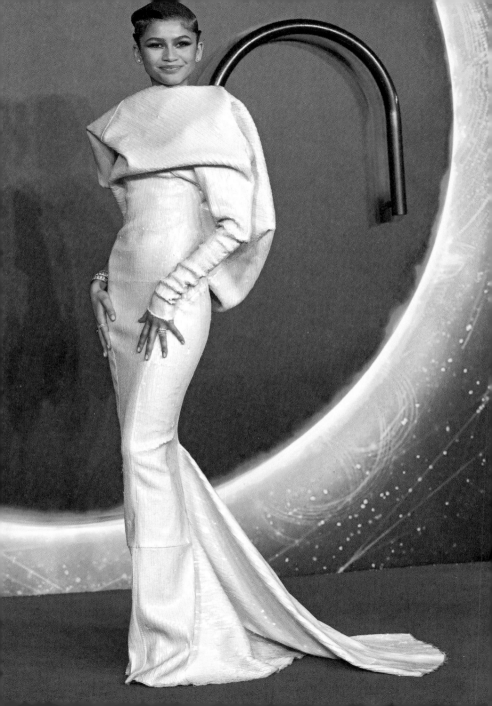

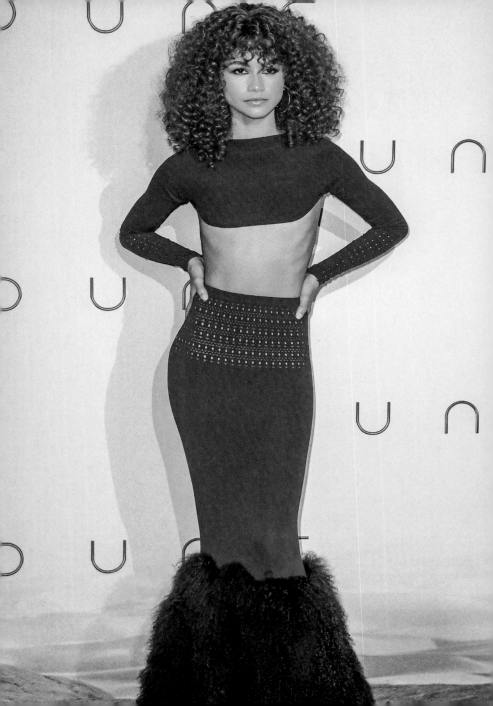

who often experiments with that sort of aesthetic, so it was only natural that she gravitated toward his designs for the occasion. When she touched down in Paris for the *Dune* premiere, she took the futuristic look in a more high-fashion direction that aligned with the look of the City of Lights. Here, she opted for a two-piece mahogany-plum hued set with feather detailing from Alaïa's spring 2022 collection.

Perhaps the most memorable *Dune* fashion moment for Zendaya came courtesy of a form-fitting wet-look, sculpted Balmain dress rendered in the colour of pale sand for the 2021 Venice Film Festival. She essentially plays a desert warrior in *Dune* and the look perfectly embodied this. The entirely custom leather gown was crafted using an exact model of Zendaya's form, down to the measurements, taking full advantage of the highly skilled Balmain atelier and artisanal tradition. "The custom Balmain haute couture was very much supposed to feel like armour and for her to feel like some type of warrior," Law Roach said in an interview with *Women's Wear Daily*. "The colour was reminiscent of the sand from sand dunes, so when we started this, we came to the conclusion that we wanted everything to feel like it could have been a costume in the movie." Likewise, the leather looked so ethereal, like a different material entirely. It was genius.

Along with designers like Rick Owens, Zendaya wore future-forward labels such as Alaïa during her *Dune* press tour.

"I think that I get to represent different types of beauty that [are] not just my own. I get to represent a lot of different types of women because of my ability to transform into these different people."

ZENDAYA

Zendaya's figure-hugging leather dress by Balmain showed off her over-the-top glammed-up style with a hint of that darker, apocalyptic look so embraced by *Dune*.

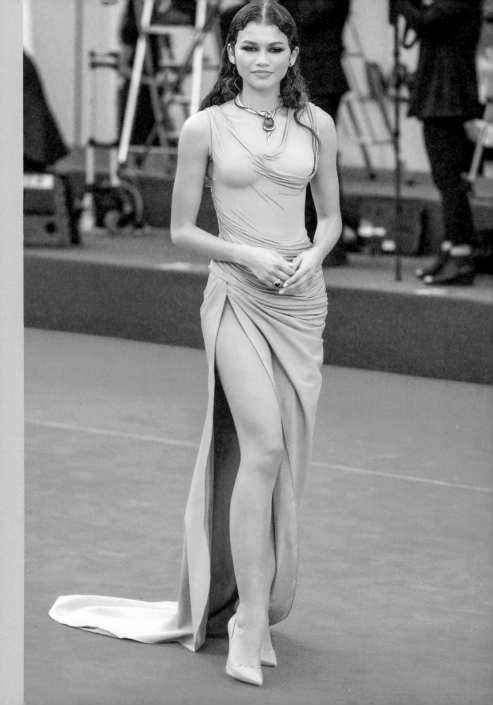

The Met Gala

Another way in which Zendaya has transformed her style is through the Met Gala. The most important event of the fashion world takes place once a year at the Metropolitan Museum of Art and is run by Anna Wintour, worldwide chief content officer of Condé Nast and global editorial director of *Vogue*. And not just any celebrity gets invited. Only the most stylish are there. Zendaya attended every Met Gala between 2015 and 2019.

As each Met Gala came around, Zendaya continued to push the boundaries of fashion and art with her risk-taking, extreme looks. Even though she had by then started wearing designs by some of the biggest fashion brands in the world, she still had a knack for turning up in looks by emerging designers. When she attended her first Met Gala in 2015, for example, she wore a sculptural red and black gown by the Italian designer Fausto Puglisi. With bejewelled white sunburst motifs and a black and white graphic trim on the sides of the train, she wore the dress with a matching gilded sunburst headband, arm cuff and bracelets. In 2016, for the "Manus × Machina: Fashion in an Age of Technology" theme, she wore a golden shimmering Michael Kors gown with her hair styled in a vintage-looking bowl-shaped bob. And for the 2017 Met Gala to celebrate "Rei Kawakubo/Comme des Garçons: Art of the In-Between", she chose a glamorous gown covered in florals and colourful parrots. The results were so striking, Rihanna herself (queen of Met Gala style) paid her compliments on Instagram.

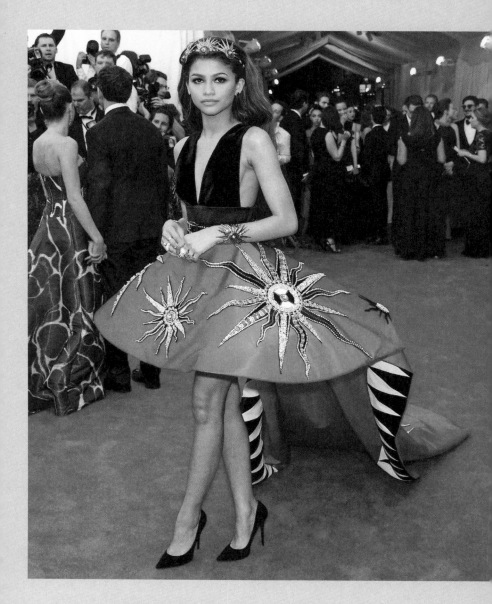

As soon as Zendaya started attending the Met Gala, she made an
immediate splash with a dress designed by Fausto Puglisi.

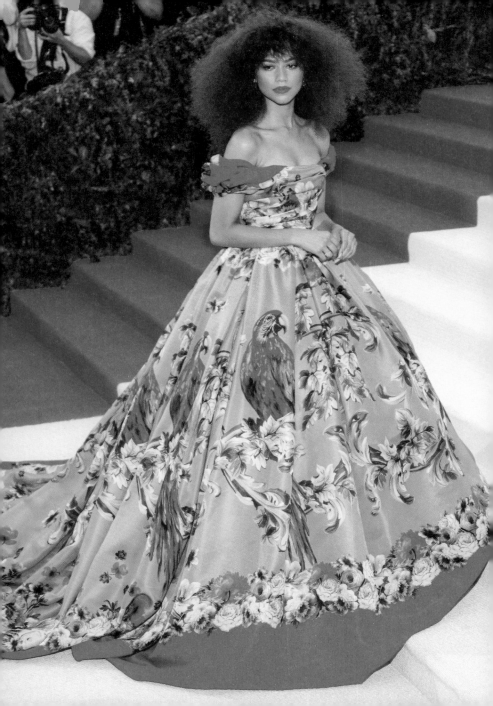

"The idea is to have fun and experiment with fashion."

ZENDAYA

At the 2017 Met Gala to celebrate "Rei Kawakubo/Comme des Garçons: Art of the In-Between", Zendaya wore a tropical-themed Dolce & Gabbana gown.

Then in 2018, she went all out, wearing a Joan of Arc-inspired silver armour dress, styled with micro bangs and a bob for the "Heavenly Bodies: Fashion and the Catholic Imagination" theme. The dress, which was definitely Zendaya's most extreme look to date, was heavy and she took part of it off after walking the red carpet. "Law, my stylist since I was 14, with the theme, he said Joan of Arc, and I kind of just went with her," Zendaya explained on the red carpet. "The idea is to have fun and experiment with fashion, and this allows me to do that every year."

Zendaya continued to push her fashion goals using the Met Gala as a platform the following year, in 2019. For the "Camp: Notes on Fashion" theme, she used the opportunity to wear something that had a highly narrative element but also offered up an element of performance. Law Roach walked the red carpet as her fairy godmother with a wand as she wore a light-up gown from Tommy Hilfiger to rival Cinderella. "Sometimes Zendaya calls me her fairy godbrother or godmother depending on how I'm acting that day," Roach told *Who What Wear*. "The story was that she was leaving Disney, and this was before *Euphoria* premiered. That was to pay homage to her career as a Disney princess." Reportedly, Zendaya even lost one of her glass slippers at the top of the infamous Met Gala stairs, making for an even more dramatic retelling of *Cinderella* to describe the ascension of Zendaya, now a household icon. This was true storytelling through the art of clothing.

OPPOSITE Zendaya's 2018 Met Gala gown was designed by Versace and inspired by Joan of Arc.

OVERLEAF Zendaya staged a performance with a Cinderella-inspired gown at the 2019 Met Gala.

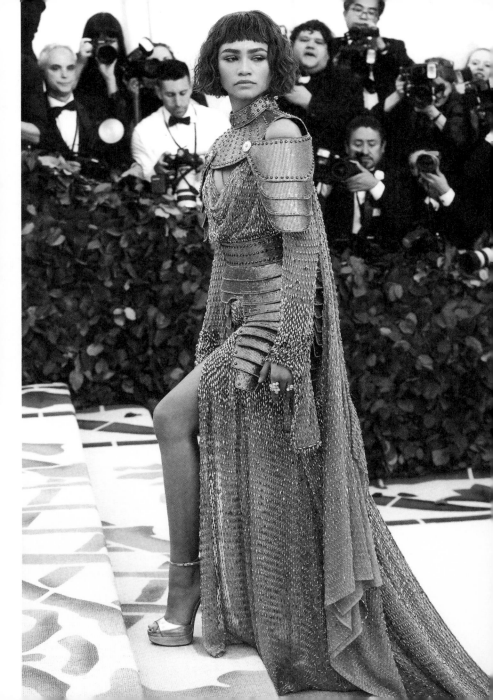

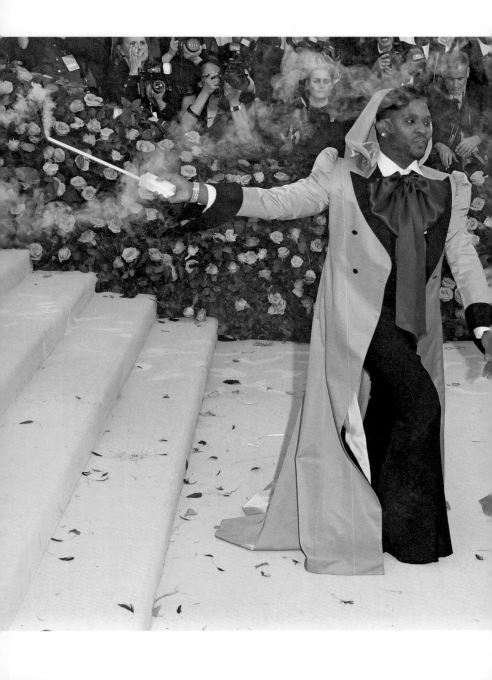

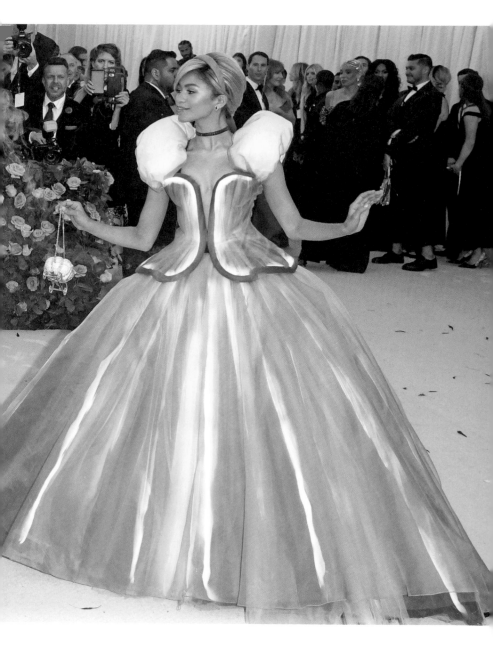

Influences and inspirations

With Law Roach by her side, styling her for every Met Gala and beyond, Zendaya has always given him ample credit for the mastermind looks she wears. In recent years, he has been outspoken about how the two have an unconventional partnership when it comes to styling, with incredible loyalty. "The way that we came into the industry, nobody wanted to touch either one of us. Like nobody wanted to lend me clothes. Nobody wanted to dress her 'cause, at that time, Disney girls weren't considered real actresses. So we pinkie swore to each other that I would do my part. She would do her part. And we would do it together," he told *New York* magazine in 2023.

Clearly inspired by high-fashion glamour, Zendaya plays the role of the glammed-up Hollywood movie star, but in a much more modern way. She has said many times that her biggest source of fashion inspiration has been her two grandmothers, but she's also alluded to being inspired by Diahann Carroll, the American actress, singer, model and activist who rose to prominence in the 1950s and 60s. She was often pictured wearing white sparkling gowns, suits and furs. Likewise, Zendaya has told reporters that she's also inspired by the style of singer and actor Cher – in particular, her sparkling dresses designed by the legendary Bob Mackie.

Zendaya with her stylist, Law Roach.

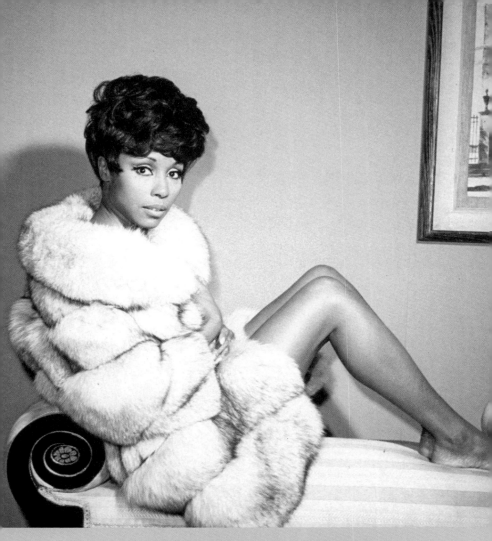

ABOVE Zendaya has said she's inspired by the style of Diahann
Carroll, the Oscar-nominated American actress, singer, model and
activist who was most well-known during the 1950s and 60s.

OPPOSITE Zendaya is also a big fan of Cher, seen here at the 1986
Oscars. Often known for her extravagant outfits, she wore this look
designed by Bob Mackie as an intentional attention-grabber after
being snubbed for her Cannes-awarded performance in *Mask*.

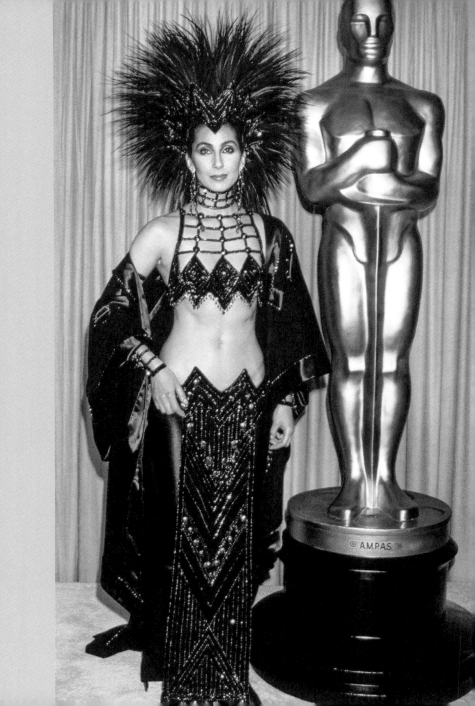

By 2018, Zendaya was a red-carpet pro, often named Best Dressed and celebrated for her style choices. Even so, years later, she would tell people, "When I put on an outfit, I will occasionally look at it in the mirror and see what poses work with the silhouette. I do think a little bit about that." She sees the red carpet a little bit differently to most people, perhaps: "I think about red carpets as having their own characters and narratives," she told *InStyle*. "We build a little story for all the looks. It's like an extension of my acting career in a weird way – you just pop this wig on or whatever it is. Clothes sometimes are very emotional, so I get to embody these different facets – maybe they're of myself, or maybe they're alter egos. But I get to meet these different women through clothes." It's a natural sort of thought process for an actress who tells people that the real stories behind her characters are what inspire her most. Such is the case for *Euphoria* (more on that later), in which she said she had so many people reach out to her and share their collective experiences of connecting with it, and the overall feelings of loss, addiction, grief, mental illness and beyond.

With all that red carpet experimentation, Zendaya was also learning about her own style, leaning into an aesthetic that felt highly personal and unique to her. From her earliest days on the red carpet, she was opinionated about what she wore. Slowly but surely, she began to integrate her own personal signatures into her style, all the while weaving in sprinkles of storytelling here and there.

No style is ever too extreme for Zendaya, like this colourblocked, oversized suit.

"*I think about red carpets as having their own* characters *and* narratives."

"*Clothes sometimes are very emotional, so I get to* embody these different facets *– maybe they're of myself, or maybe they're* alter egos."

ZENDAYA

Designers, Stylists

CHAPTER 3

and Major Moments

Zendaya has always supported emerging designers before many of her rising colleagues embraced their work. Naturally, this is also courtesy of Law Roach, who has a keen talent and knack for finding the next important voices in fashion. In 2019, while Zendaya was on tour for *Spider-Man: Far From Home*, she opted for a steady rotation of outfits designed by Peter Do, the Vietnamese-American fashion designer who is also a Celine alumnus. Just a few years later, Do would be named the new creative director of Helmut Lang, in 2023. "The woman I am speaking to is defining a new kind of glamour," Do said of his menswear-influenced designs, which won him an inaugural LVMH Graduates Prize in 2014. At just age 23, he went to work at Celine, alongside industry icon Phoebe Philo, who would later become a mentor to him. He later transferred to New York to work under Derek Lam, launching his namesake brand in 2018.

Zendaya has always supported emerging designers. Here, she wears a suit by Peter Do, newly rising designer at the time.

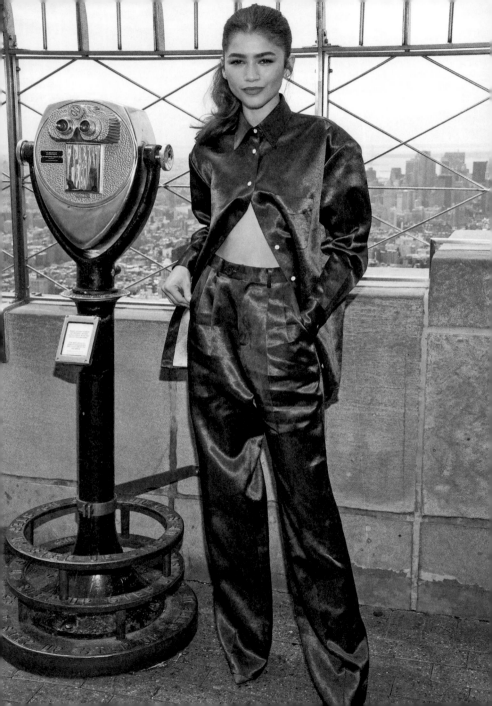

Emerging designers

What Zendaya loved about Do's work were the minimal designs, clean lines and gender-neutral, masculine details. For an event that took place on top of the Empire State Building on June 24, 2019, she donned a shiny top and pant set in the deepest shade of navy blue, the top unbuttoned to reveal a hint of flesh just below the bust. The same day, outside the offices of the television show, *Good Morning America*, she chose to wear a sheer white dress over pants, printed with linear graphics and the shapes of different car parts, fresh off the runway from Peter Do's Autumn/Winter 2019 collection.

"There's an intentionality to every request and conversation we have with Law, which is quite rare," Do told *Vogue* of working with Roach. "[He] helped boost [our] international visibility and generate interest in the brand, as it was just our second season." That focus on lesser-known designers was entirely intentional. "We've been able to build out our careers using emerging and independent smaller brands and designers. Because I think when we first started, we were looked at as emerging...so that's how it was," Roach told *Women's Wear Daily*. "If you look at the things she wears, she [Zendaya] still wears a lot of independent, emerging designers. Peter Do, Christopher Esber, Christopher John Rogers. We stick to that identity because it's worked for us and it actually feels really good."

Peter Do's minimal, sleek suiting has always
aligned well with Zendaya's style.

Zendaya making a statement through what she wears is an inherent part of her style lexicon. For her *InStyle* 2020 cover story, she purposely chose to only wear emerging Black designers. She wore pieces from Jason Rembert, Christopher John Rogers, Anifa Mvuemba, Kerby Jean-Raymond and Carly Cushnie, among others, including a bright red, blue and yellow pleated Hanifa dress designed by Anifa Mvuemba. She also shone bright in a red satin Aliétte dress, designed by Jason Rembert for his 2020 fall collection, and earrings by Matthew Harris of Mateo New York. She also wore a pink chequered gown by Christopher John Rogers which made an extremely dramatic impact – plus, other options from Romeo Hunte, Thebe Magugu and Victor Glemaud. With Law Roach by her side, she assembled an all-Black creative team for the cover's photoshoot, including the photography duo Ahmad Barber and Donté Maurice. She has declared that if she ever becomes a film-maker, the leads in her films will always be Black women.

When 2019 rolled around, Zendaya created her first big-name fashion collaboration with Tommy Hilfiger. This wasn't just a small-time collaboration either – it was a global fashion moment, which took place at Paris Fashion Week, the glittering Crown Jewel of the fashion industry. For the first time in Tommy Hilfiger's history, the label showed in Paris with Zendaya standing in as the face of the brand and the genius collaborator behind the collection, dubbed *TommyNow*. At the time, the then-22-year-old actress had more than 54 million followers on Instagram, drawing plenty of attention to the legacy brand with a younger, newer point of view. For starters, Hilfiger and Zendaya were inspired by The Battle of Versailles, the legendary 1973 Paris Fashion show that pitted French designers including Yves Saint Laurent and Hubert de Givenchy against up-and-coming American talents like Bill Blass and Halston. Some of the models who walked Zendaya's show had walked The Battle of Versailles show too – including Pat Cleveland, who wore a shining asymmetrical dress, twirling down the runway as she went. The American model and activist Bethann Hardison was also present at The Battle of Versailles and Zendaya's show, and was spotted cheering.

OVERLEAF Zendaya's Tommy Hilfiger show in Harlem (2019) was a celebration of 1970s style and Black culture.

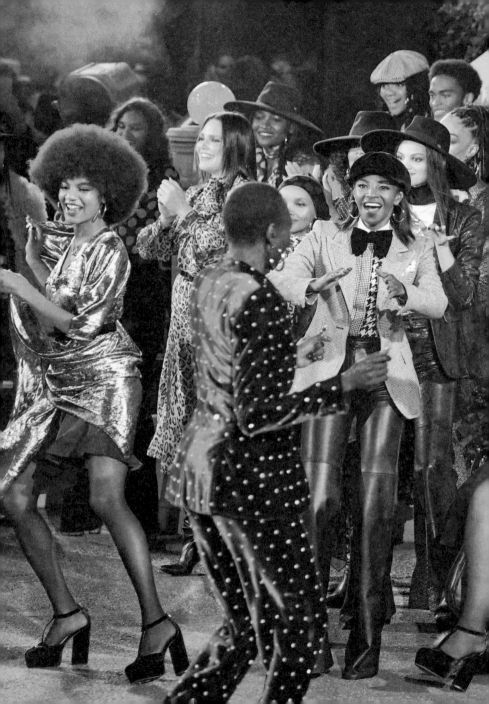

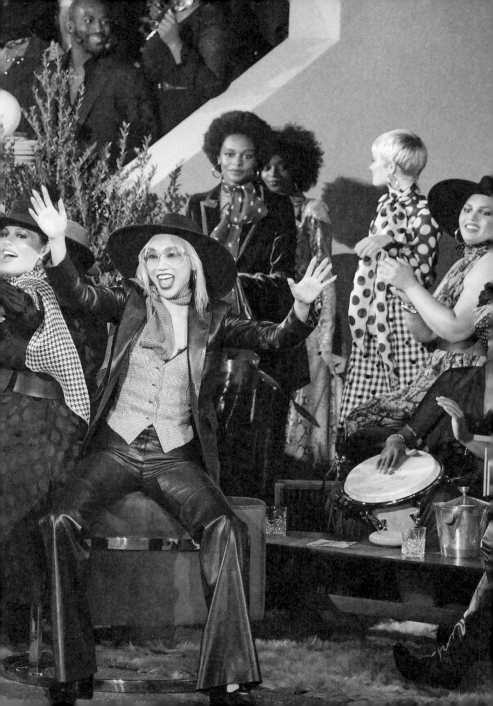

The Tommy Hilfiger years

It was clear that if Zendaya was going to show at Paris Fashion Week, she was going to do it her way. For the Tommy Hilfiger show, the runway featured an all-Black cast of women of all ages and shades, shapes and sizes. Taking place at the landmark Comédie des Champs Élysées theatre, the runway was streaked with neon red, white and blue colours while neon signs hung behind it. The models showcased a powerfully dynamic collection rooted in 1970s aesthetics. Jourdan Dunn, Winnie Harlow, Beverly Johnson (the first African-American model to appear on the cover of American *Vogue*), Veronica Webb and others walked the runway. Newcomers and fan favourites were also there, like Halima Aden, the model known for being the first woman to wear a hijab in the Miss Minnesota USA pageant and the trans actress and model Leyna Bloom. For the occasion, Aden donned a sleek trench coat with a matching hijab. As for the final model to walk the show? It was the ever-iconic Grace Jones, then 70 years old, who closed the show wearing a golden glimmering lurex leotard bodysuit, a striped metallic blazer and knee-high boots, looking as fabulous as ever.

At Zendaya's Tommy Hilfiger show in Paris, the iconic singer-songwriter amd model Grace Jones walked the runway and closed the show.

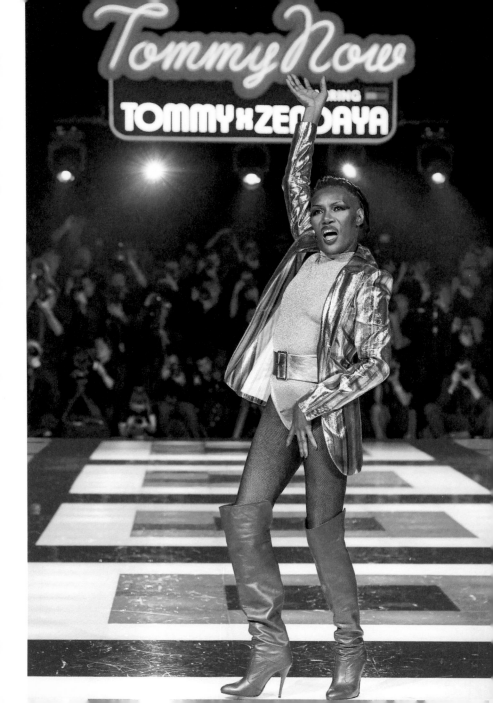

"We build a little story for all the looks. It's like an extension of my acting career in a weird way."

ZENDAYA

People love Zendaya because of her fashion and her positive attitude, but also because of her activism for inclusivity. Here at Paris Fashion Week – historically non-inclusive of age, size, race and shape – Zendaya broke down all those barriers to deliver a fantastic example of how being inclusive and diverse is not only possible but also much-needed. Unlike the other brands that showed at Paris Fashion Week – some of the biggest names in the world – Zendaya gave the world something to look at that felt relatable and current. This was something that young girls and women across the globe could look up to and see themselves reflected back. "More than a celebration of Blackness, Zendaya's collaboration was a reminder that inclusivity isn't just about who gets to walk the runway, it's about who gets to sit at the table," *Vogue's* Chioma Nnadi wrote in her review. Zendaya in turn was adamant about the casting being vital to the collection. "I feel like we are paying homage to these women who changed our legacy, and who allowed me and so many others to be here," she told the *New York Times*.

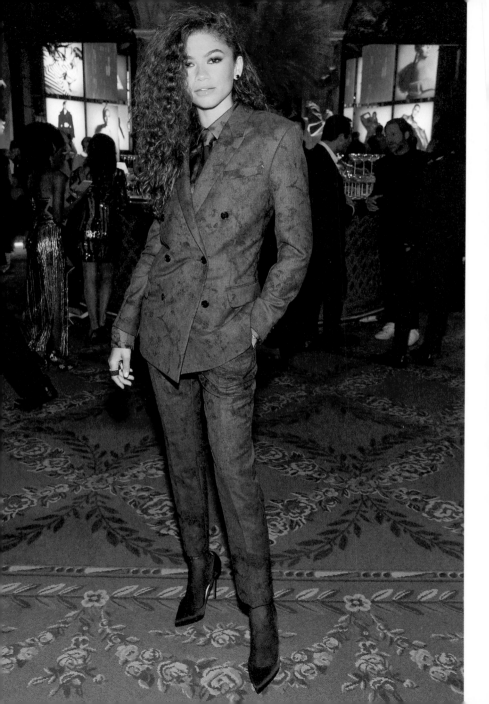

As for the clothing, there were slinky striped dresses with big golden belts, tailored short suits, plenty of striped denim, shining lurex slip dresses and colourblock halterneck dresses. The collection was highly wearable but still leaning toward an editorial, high-fashion direction. With the *New York Times*, *Vogue* and other media outlets praising the collection, this was widely considered a success and Zendaya's greatest foray into the world of fashion yet. Janelle Monáe and models Tyra Banks and Gigi Hadid and actress Yara Shahidi were just a few of the front row guests who showed up in support. But perhaps part of the reason why the collection looked so naturally good was that it mirrored Zendaya's own personal style, with elements of masculine suiting and all things gender-neutral. As always, by her side was Law Roach, who was behind the scenes collaborating with her on the vision.

Looking back to the 1970s for the collection was a natural reflex for both Zendaya and Roach, and it made sense for Tommy Hilfiger too, who told the press he remembered seeing these same kinds of styles on the dancefloor of the legendary nightclub Studio 54 in New York City. Remember, also, Law Roach started his career in the retail business by owning a vintage store. And Zendaya spent her formative teenage years playing dress-up in his vintage store in Chicago. She has often said that it was during those moments, going through those racks, that she gained an appreciation and understanding for fashion from the past.

Here, Zendaya wears one of her favourite
wardrobe staples, a well-tailored suit.

After a successful first season, Zendaya was tasked with taking her personal style to the next level with Tommy Hilfiger once again. The starlet debuted a second season of her TommyNow collection, this time at another major platform in the fashion industry: New York Fashion Week. On a mild October day in 2019, she took the fashion industry and a slew of celebrity guests to the landmark Apollo, the Harlem music hall – an incredibly historic venue that has hosted some of the most iconic Black performers in the world. "It's a place that has such history and soul, it's a dream location," she told *Vogue*. "I've always wanted just to come here, and we wanted to pay homage to the people who paved the way for me to even be here in this space."

The Apollo was transformed into an outdoor space, full of old cars, live jazz musicians and a cast of characters scattered throughout and outside the block in front of the venue. Unlike a traditional runway format, guests were treated to a scene that looked as though it were taken from a movie. Guests sat in football-field style stadium above the manufactured set. As for the clothing, Zendaya continued to riff on a vintage-led aesthetic from the late 1970s and into the early 1980s, with a particular bent leaning toward her personal style. By this point and time, everyone had recognized her affinity for menswear and suiting. Here, she

showed it in spades. She was also inspired by two of her forever style icons: her grandmothers. When designing the collection, she was thinking of how they owned a lot of these kind of clothes. "Many of the looks were taken directly from her life," she told *Vogue*. "I'm looking to the effortless chic of that time period; this is my fantasy of that era."

Once again, it was a natural progression of the Tommy Hilfiger x Zendaya collaboration, given Hilfiger's history with the era. After all, the brand launched in 1985 and played with the familiar 1970s silhouettes often. As with the last collection, Law Roach remained a silent but strongly present collaborator in the collection, offering up his own styling for the runway too.

The cast this season was equally diverse as Zendaya's last collaboration with the brand. And the front row was just as sparkling, with Jameela Jamil, Meghan Trainor, sisters Bella and Gigi Hadid, Georgia Jagger and Suki Waterhouse plus Zendaya's *Euphoria* castmates, Barbie Ferreira, Sydney Sweeney and Hunter Schafer, watching the show. The native Harlem style legend, Dapper Dan, also showed up. All in all, it was a strong collection that marked the end of Zendaya's partnership with Tommy Hilfiger (for now) and left her with major experience that would set the tone for her next chapter in fashion.

"She is a *powerful and fierce young woman* that uses her talent and her work to express herself, her **values** and her generation as well."

**PIERPAOLO PICCIOLI,
VALENTINO
CREATIVE DIRECTOR**

The Valentino years

Zendaya's biggest high-fashion break yet came when she became an ambassador to the house of Valentino. News of her appointment was announced in December 2020. The decision came courtesy of Valentino creative director Pierpaolo Piccioli himself. "The reason why we chose Zendaya as the new face for Valentino is because she perfectly embodies and represents what Valentino is and stands for today," he told *Women's Wear Daily* at the time. "She is a powerful and fierce young woman that uses her talent and her work to express herself, her values and her generation as well." The partnership came at a time when Zendaya's career was skyrocketing and she was getting the much-needed recognition she deserved for her acting work. Just a few months prior to the Valentino announcement, she made history at the Primetime Emmy Awards as the youngest winner, at age 24, of Outstanding Lead Actress in a Drama Series for her role in the TV drama *Euphoria*. She also made history as the second Black actress, joining Viola Davis, to win in the prestigious category in the show's 72 years.

OVERLEAF Zendaya wears a Valentino Pink suit and accessories head to toe, outside the label's Paris Fashion Week show.

Piccioli intentionally chose Zendaya not just for the way she dressed, but because of her community and values. "I wanted to shift the idea of Valentino muses from lifestyle to more of a community, meaning that you choose people because of what they stand for, not just for what they represent or for their physical beauty," he told W magazine in 2022. "So, Zendaya and Frances McDormand and Glenn Close are all completely different, one from the other, but they share a strong individuality, a real uniqueness, and a sense of values."

While at Tommy Hilfiger as an ambassador and collaborator who co-designed collections, Zendaya was able to hone in on her vintage-inspired, youthful style. But at Valentino, she was able to get in touch with a new side to her personal style. One that was more glamorous than ever before, and highly connected to high-fashion craft. Tommy Hilfiger, after all, is an American sportswear brand that mainly focuses on casualwear. On the other hand, Valentino is a luxury European fashion house with decades of experience in the best-of-the-best ateliers and craftsmanship, not to mention the ability to produce and present couture at Paris Fashion Week. In the world of fashion, couture is the elite, highest end sector of fashion – produced entirely by hand.

"[Zendaya] perfectly embodies and represents what Valentino is and stands for today."

**PIERPAOLO PICCIOLI,
VALENTINO
CREATIVE DIRECTOR**

The yellow dress Zendaya wore in April 2021 was one of the best examples of the collaboration between muse and house. For the occasion, Zendaya was presenting at the Academy Awards. Piccioli, Roach and the Valentino team wanted to do something sophisticated and daring that would challenge the status quo. With Zendaya on board, everyone decided: yellow would be the most unexpected colour for a dress with the silhouette of a gown with couture draping. With a bright cut-out at the torso and matching heels, it was a gown that didn't fade into the background but rather proclaimed Zendaya as the style icon she is. The finishing touch? A surprising $6 million worth of Bulgari jewels. Zendaya has long said she's a big fan of Cher's personal style and this look was also a subtle nod to the 70s style siren. It was a direct reference to a jumpsuit Cher wore on *The Sonny & Cher Show* in 1970, as well as the glittering Bob Mackie gown she wore to the Academy Awards in 1973.

Zendaya's neon-yellow Valentino dress was the epitome of taking a fashion risk and having it pay off big time.

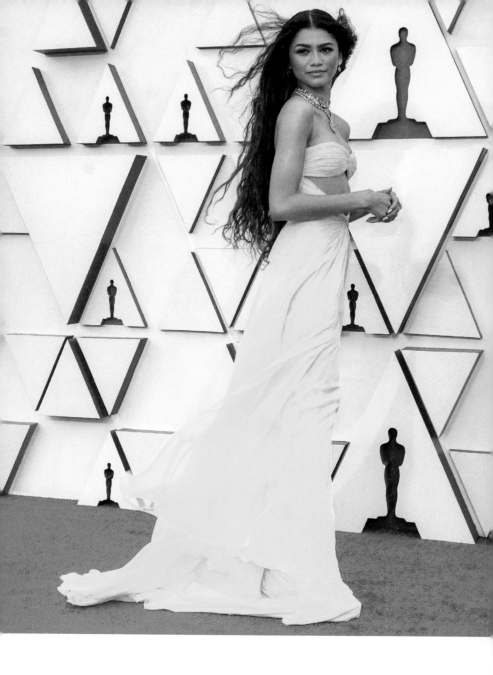

While working with Valentino, Zendaya was able to get in touch with her love of vintage, though in a completely different aesthetic lens to what she had while collaborating with Tommy Hilfiger. Take, for instance, the strapless black and white vintage Valentino gown she wore to the 2022 HBO *Euphoria* Season 2 premiere. To celebrate the moment, Zendaya uploaded a series of photos to Instagram of Valentino Garavani alongside model Linda Evangelista, who wore the same dress on the runway in the 1990s.

And while her ensemble worn to the 2022 Oscars wasn't true vintage, it was vintage inspired and it was Valentino. Zendaya wore a white Valentino haute couture cropped button-down top with a silver glittering sequined skirt, which many compared to the outfit Sharon Stone wore to the 1998 Oscars, when she famously paired an evening skirt by Vera Wang with a white, button-down shirt from Gap. At the time, Stone's look was considered boundary-breaking. For Zendaya, who often takes a page from iconic style icons who do their own thing, it was a very natural fit.

Zendaya loves bold, bright colours but she also knows how to make neutrals interesting; as seen here with a black and white gown.

"I'll tell you what the coolest thing is. When [Valentino creative director] Pierpaolo [Piccioli] has my name stitched on a little tag inside. So all my custom Valentino pieces have a little "Zendaya" on them."

ZENDAYA

The ultimate high-low: Zendaya plays with a casual white button-down and sequin maxi skirt on the red carpet.

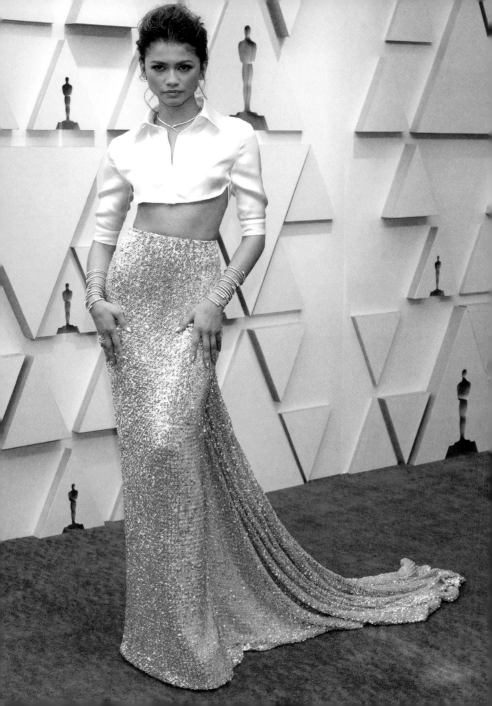

Zendaya was leaning into her own personal style on a deeper level than ever before. Maturing into wearing structural gowns with a great emphasis on craft, each time she picked something for the red carpet, there was an inherent story behind it with plenty of references for onlookers to catch. Credit that to her partnership with Law Roach and her love of vintage, but either way, she wasn't opposed to wearing pieces that could be understood as "classics", especially when she put her own visual narrative spin on it.

For the 2022 Emmy Awards, in which she was nominated for Outstanding Lead Actress as Rue Bennett in *Euphoria*, the then-26-year-old opted for a black Valentino ball gown that appeared effortlessly glamorous from another time period. With its sculptural peplum, dramatic ballroom skirt and flowing train, the dress was inspired by outfits worn by 1950s style icon and actress Grace Kelly as well as a look from Valentino's fall 1987 collection worn by Linda Evangelista in a Steven Meisel ad campaign. In an interview with *Vogue*, Law Roach said, "Zendaya and I were also really inspired by Valentino's fall 1987 collection. There was a red dress that Linda Evangelista wore in an editorial, and we took inspiration from the bodice of the dress – but we made it black and the skirt a *lot* bigger." The dress was actually a surprise choice. According to the stylist, Valentino crafted three dresses for the awards show, but Law Roach said the perfect design came to him magically in a dream. And so, the final black dress (which had pockets!) was fully put together in just one week.

Never afraid of a classic, Zendaya sometimes keeps it simple (but elevated) with luscious silhouettes in neutrals.

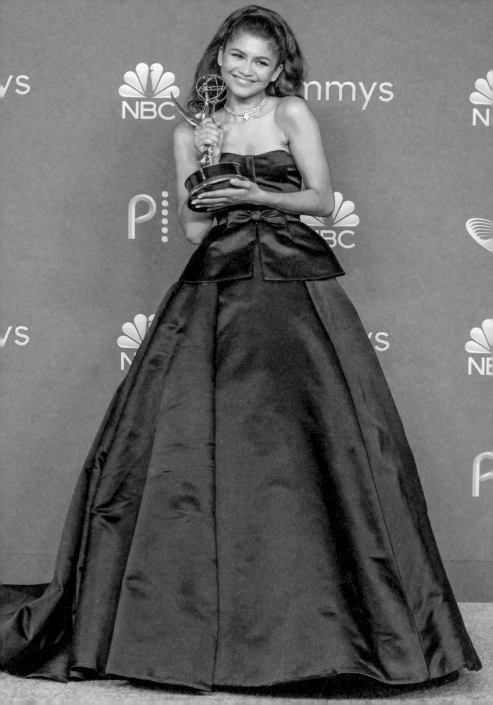

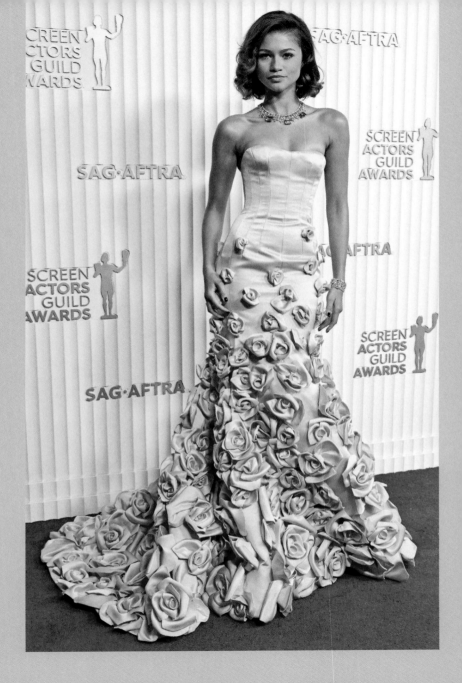

In February 2023, Zendaya wore one of her most iconic Valentino looks of all time, a brilliant blush pink strapless gown covered in a sea of sculpted rosettes. According to the house, the gown took 1,230 hours of work, with 190 hand-embroidered roses. Each rose took a total of 5 hours of sewing, with 42 different people involved in the making process.

Even after all the gowns and extreme glamour, Zendaya still got emotional about the experience of wearing one-of-a-kind fashion created just for her. "I'll tell you what the coolest thing is. When [Valentino creative director] Pierpaolo [Piccioli] comes up with these beautiful silhouettes for me to wear, he has my name stitched on a little tag inside. So all my custom Valentino pieces have a little "Zendaya" on them," she told *InStyle*.

One of Zendaya's most iconic Valentino looks, pictured here, took 1,230 hours of handiwork to make.

The Louis Vuitton years

In 2023, Zendaya took the next step in her fashion journey, leaving Valentino behind to become one of the newest ambassadors to the house of Louis Vuitton. This meant trading attending Valentino's Paris Fashion Week shows and getting the custom design treatment from Piccioli to now attending Louis Vuitton's shows and collaborating with Nicolas Ghesquière, the French-Belgian fashion designer who has been the women's creative director of the house of Louis Vuitton since 2013.

If Piccioli represented the bold and bright side of high-fashion glamour, Ghesquière was the more risqué fashion rebel who took a more intellectual approach to fashion with subversive silhouettes and a heavy emphasis on the heritage of the brand. Her newfound partnership also mirrored the big steps her career was taking. The year 2023 was incredibly impactful for her, after all. The trailer was released for *Challengers*, Luca Guadagnino's tennis drama in which she stars, and she was at work filming the second instalment of Denis Villeneuve's sci-fi film series, *Dune*.

OPPOSITE In 2023, Zendaya became a Louis Vuitton ambassador and started wearing streamlined, experimental pieces from the brand.

OVERLEAF Zendaya and her stylist Law Roach, outside a Louis Vuitton fashion show in Paris.

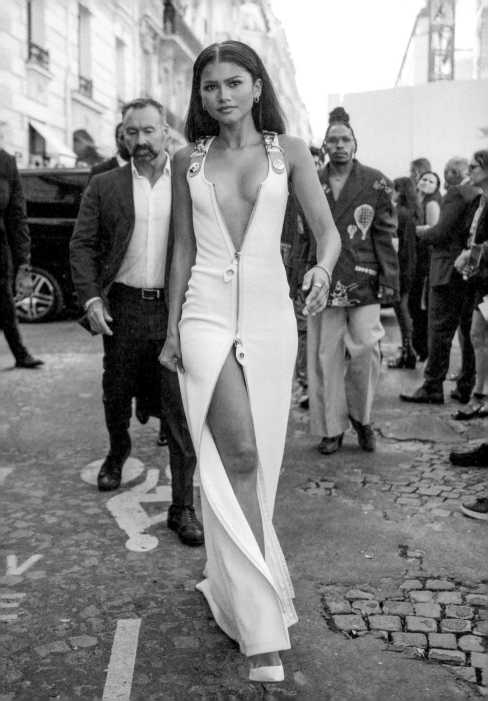

"I remember growing up around LV campaigns."

ZENDAYA

Zendaya's sense of fashion has continued to develop while partnering with Louis Vuitton. She often experiments with different textures, as seen here.

Louis Vuitton unveiled its partnership with Zendaya by releasing a campaign with her posing as the face of their iconic Capucines bag in April 2023. Pictured wearing sleek black clothing, and holding the chic little bag, the campaign was photographed at E-1027, the house in Roquebrune-Cap-Martin designed by the Modernist architect and designer Eileen Gray. The photographers were the duo Mert Alas and Marcus Piggott – and, of course, the stylist was her long-time collaborator Law Roach. Zendaya previously had her focus on shoes and clothing as a fashion ambassador, but this was the first time she stepped into handbag territory. Albeit, this is one of Louis Vuitton's most iconic bags. The Capucines bag launched a decade prior to her campaign and is named after the Parisian street where Louis Vuitton's first store was located in 1854. It's a boxy little shoulder bag crafted in premium leather, with a top handle and crossbody strap options.

For Zendaya, starring in the Capucines campaign was steeped in nostalgia. "I remember growing up around LV campaigns," she told *Vogue*. "There was this one that I loved from the early 2000s of Naomi Campbell, and she's like sprawled out over a trunk. I can still see it. I can see the image in my head and I remember seeing it in magazines as a kid." One of her earliest memories of Louis Vuitton came courtesy of the LV monogram-inspired designs she saw on the social media platform Myspace during its heyday in the early 2000s. "Everyone had the LV-print on their Myspace page," she told *Vogue*. "At least I had that! Let me not try to put that on nobody else. That was definitely me."

With Pharrell Williams, record producer, songwriter and men's then-creative director of Louis Vuitton.

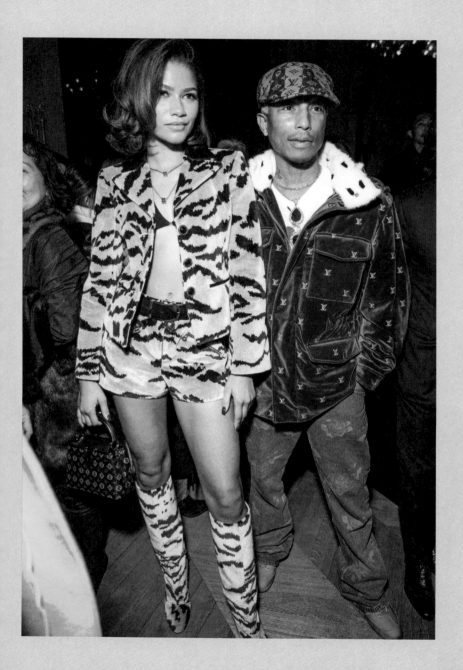

At the labels where Zendaya had previously served as ambassador, the handbag category wasn't a major part of the business as it was with Louis Vuitton. As the actress would continue her ambassadorship with the house, her loyal fans would get to see her style outfits with various bags from all different eras of the Louis Vuitton universe. When Louis Vuitton presented its Spring/Summer 2024 show at Paris Fashion Week in fall 2023, Zendaya was spotted later in the day (and after the show) carrying the Theda bag, which launched in the mid-2000s. The colourful rainbow monogram print bag has a definitive Y2K aesthetic, with a big buckle, short top handles and two drawstrings.

During her era at Louis Vuitton, Zendaya spent a lot of time trying on different bags – something we hadn't previously seen from her. It allowed her to express a new dynamic layer of her personal style. During this time she showed her preference for hands-free, small bags like the crossbodies that she can take with her everywhere. Her main requirements in a bag? It has to fit her phone, lip gloss and a little camera. On the rare occasion when she does use a big bag, she really goes all out. She has said that she is one of those people who really like to *fill* their bag. Big enough for a laptop plus more, or it's not enough.

"I feel like we are paying homage to these women who changed our legacy, and who allowed me and so many others to be here."

ZENDAYA

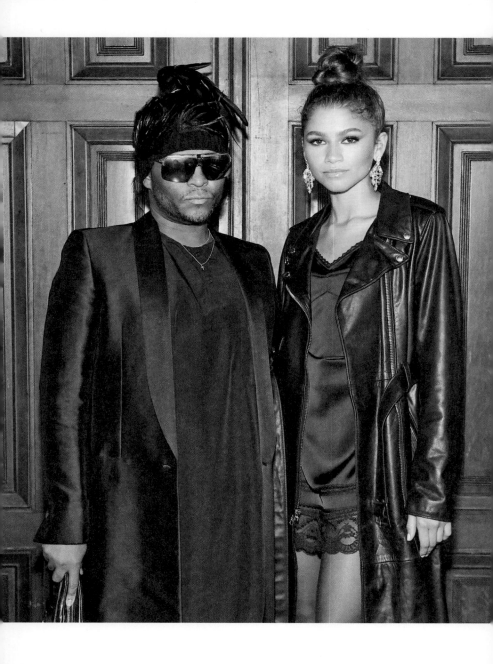

When it came down to the clothing in Zendaya's Louis Vuitton era, it was all about the archives too. Rather than wear completely custom-made creations, she and Law Roach went back to past designs from the brand. In the days following the Spring/Summer 2024 show in October 2023, she wore an asymmetrical shouldered top and skirt with printed graphics from Nicolas Ghesquière's resort 2015 collection for Louis Vuitton. Black leather, thigh-high boots completed the look. Later on, she opted for a gold ruched crop top, light wash jeans and white sandals – plus that eponymous aforementioned rainbow monogram bag. This look was from designer Marc Jacobs' tenure at Louis Vuitton as creative director, specifically his Spring/Summer 2004 collection. Naomi Campbell originally modelled the bag in the brand's campaign when it first debuted.

Zendaya and her stylist Law Roach have an incredibly close relationship and often attend events together, as seen here.

"For me, it's one or the other: It's either all about the jewels and it's stacking and layering and very heavy, or it's minimal and just there to complement the outfit."

ZENDAYA

Zendaya carries the Louis Vuitton rainbow monogram bag during Paris Fashion Week 2023.

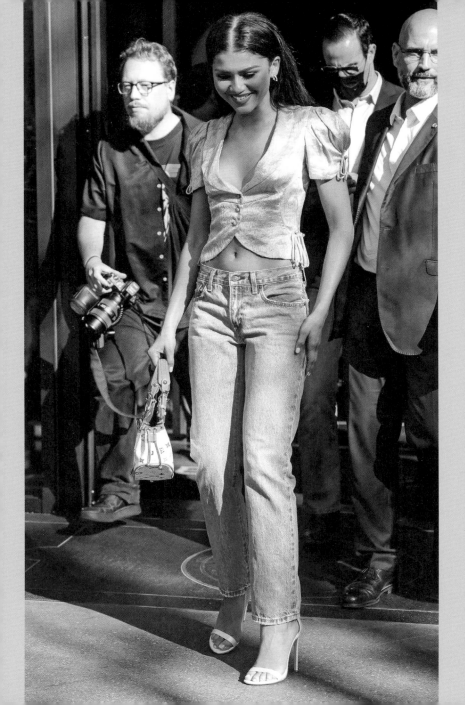

Zendaya seldom wears accessories when she's off duty, but on the red carpet, she opts for beautiful Bulgari jewels. That's another chapter of her ambassadorships as she was named a Bulgari ambassador in 2020. In her everyday life, she prefers wearing a few rings and maybe a chain. One of her favourite rings is inspired by a memory. One of her big sisters wore an emerald green ring growing up and for Zendaya's 18th birthday, she gifted Zendaya a little emerald green ring. "For me, it's one or the other: It's either all about the jewels and it's stacking and layering and very heavy, or it's minimal and just there to complement the outfit," Zendaya told *Vogue* of her personal style when it comes to jewels – specifically on the red carpet. "It can go either way; it just depends on the look or the feeling behind what we're doing. But it's so funny to me how an earring can change everything. When you're feeling like, 'Oh, I need to dress this up,' you put on a little set and you're like, '*Okayyy.*'" Even beyond fashion, her influence cascades into beauty, with partnerships with Lancôme, CoverGirl and Chi Haircare, just to name a few.

Zendaya has been a partner of the luxury brand Bulgari and often wears the jewellery at events or on the red carpet.

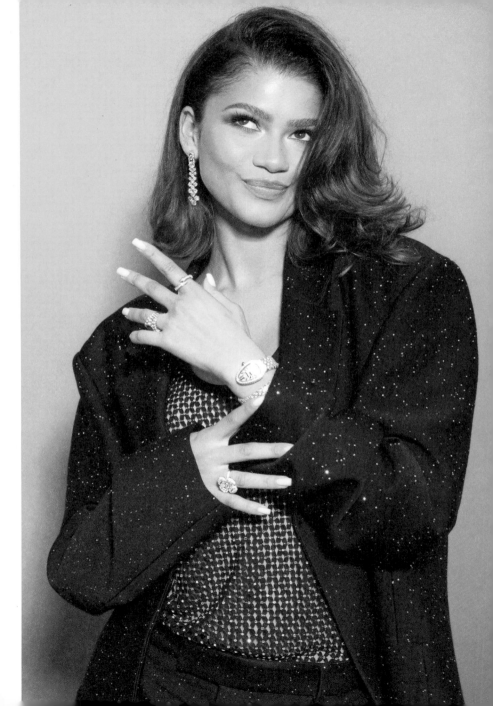

The Next Generation

CHAPTER 4

of Style

Zendaya's style influence was celebrated on another level in 2021. The then 25-year-old became the youngest person ever to win the Council of Fashion Designers of America's Fashion Icon Award in 2021. A massive honour in the industry, the event is associated with *Vogue*'s Anna Wintour and attended by many of the top designers in the field as well as a host of A-list celebrities. Zendaya could barely suppress her emotions after receiving her award from the iconic model Iman and she listed Cher, Diana Ross and her grandmothers as her own fashion icons.

Iman's speech at the CFDA Fashion Awards reconfirmed Zendaya's global influence as an actress and singer who stands as a style icon. She spoke of her fearlessness as well as her instincts on the red carpet, as well as how Zendaya has redefined the notion of glamour for an entirely new generation of fashion fans. Iman said that Zendaya transcends any known definition of celebrity style: "Zendaya reminds us all that true icons must always be brave," she said. "And they will be forever ageless."

Zendaya wears a colourful, short suit set designed by Jeremy Scott for Moschino.

"Fashion did something for me. It gave me the **extraordinary** *gift of transformation."*

ZENDAYA

Zendaya is experimental with colour and often wears jewel tones, as seen here.

Wearing a cherry red sculpted crop top and blazer with a voluminous cloud-like skirt to match, Zendaya opted for American designer Vera Wang for the ceremony. She called fashion a creative outlet of expression and compared it with all the reasons she loves acting. "I was a really, really sad kid, and I still kind of am," she revealed. "But fashion did something for me. It gave me the extraordinary gift of transformation." She also spoke of embodying a range of characters and attitudes through the way she dresses.

OPPOSITE In 2021, Zendaya became the youngest person ever to win the Council of Fashion Designers of America's Fashion Icon Award and wore Vera Wang for the occasion.

ABOVE Along with her fashion partnerships, Zendaya has been an ambassador for beauty brand Lancôme.

The *Euphoria* years

On screen, Zendaya continued to build her characters with their own style. In *Euphoria*, she further cemented her status as style icon by playing the character Rue Bennett. The show, with its cult following, attracted an entirely new generation to her fan base and put her on the map in a new sort of way. Here was a platform where Zendaya could show off her true acting chops like never before – as a young adult struggling with addiction problems in a social media-driven world. Alongside her colleagues, including Sydney Sweeney, Maude Apatow, Alexa Demie, Jacob Elordi, Barbie Ferreira, Eric Dane, Storm Reid and Nika King, the show became known for its make-up and style influences. While Sweeney was known for her saccharine-sweet outfits doused in femininity, Maddy (Alexa Demie) was all about Y2K glam. On the other hand, Zendaya stood out as Rue, with her lack of make-up, baggy clothes, hoodies and casual gender-neutral clothing that very much leaned toward the Tomboy direction.

Euphoria costume designer Heidi Bivens took inspiration from people in the real world for each of the *Euphoria* characters. In the case of Rue, Zendaya had a real-world direct impact on the wardrobe of her character. She suggested to Bivens that Rue wore little boys' Hanes tank tops, as inspired by her own real-life wardrobe. Bivens bought them, dyed and styled them to fit into Rue's main character wardrobe. Zendaya also embraced her love of vintage through *Euphoria*. In the first episode of Season 2, while everyone else is wearing dresses at a house party, Rue opts for a Jean Paul Gaultier vest and vintage Roberto Cavalli pants.

Likewise, throughout Season 1, Rue sports her dad's burgundy sweatshirt. As always, the outfits are integral to the storytelling. "I think we almost only ever saw her in the hoodie in season one," Bivens told *Vogue*. "With a character like her, if she only ever wore that hoodie, she would lose it. She will definitely lose it. It's like a baby blanket that gives her comfort, and I think it's very precious to her, so it's always somewhere. It's probably one of the only things she owns that she knows where it is." The inspiration behind that was also a bit biographical. "When I was 11, my grandfather passed, and we had all his old clothes," Zendaya told *Allure*. "I thought it would be cool if we made [it clear that] the hoodie was Rue's [late] dad's hoodie. [I wanted to capture] that attachment that you have to inanimate objects when somebody passes."

Zendaya also admitted the influence of *Euphoria* on her real-world wardrobe, explaining that she's embraced a closet full of vintage T-shirts and oversized sweaters. "I think Rue has a lot of really cool vintage pieces that made me want to start getting more vintage T-shirts and things like that," she told *InStyle*. "She definitely came through for me in the comfort side of my style."

OVERLEAF In the TV drama *Euphoria*, Zendaya became known for her casual, tomboy outfits.

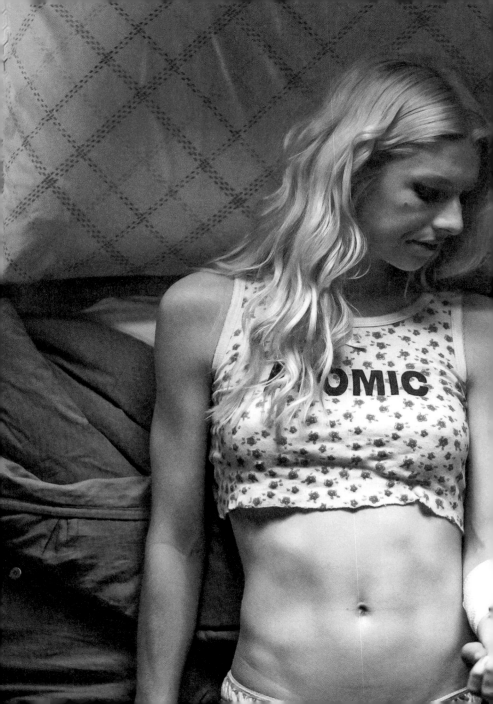

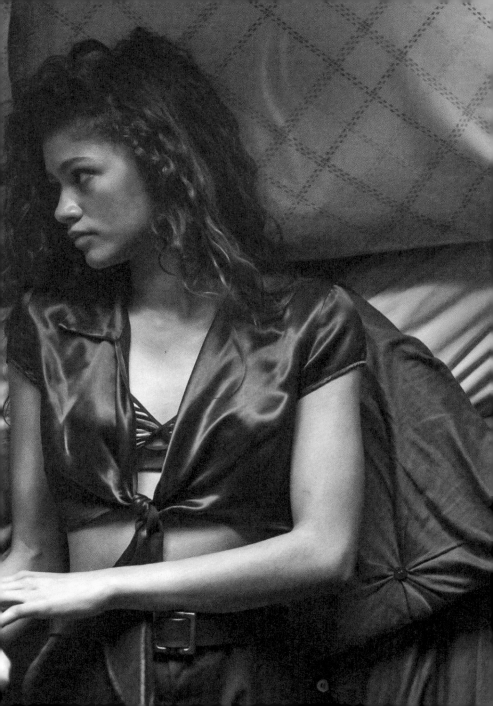

It also turned out that starring on such a visually distinct show would make Zendaya rethink fashion entirely. For her *InStyle* cover shoot in 2021, she self-directed some of the shots, curating her own aesthetic through visual image. "I've always been interested in things behind the camera," she told *InStyle*. "But *Euphoria* really grew my love for cinematography, just watching Marcell Rév light things and make every frame gorgeous. He and [series creator] Sam Levinson build these beautifully intricate shots and put so much detail into everything. I'm a Virgo and I like to be thoughtful of everything. But watching them work inspired me to get more into photography."

The filming of *Euphoria* Season 2 collided with the period of time when the world went into lockdown due to the pandemic, and that also had an impact on Zendaya's personal style. Rather than spending hours on set or days rehearsing her lines, she turned to dressing up, trying on different wigs from her extensive collection and taking photos to document the process. She gravitated toward a red bob as well as a stick-straight 1970s Cher redux. But she remained restless and ended up filming *Malcolm & Marie* (2021), a story about a clashing couple in love. John David Washington starred alongside Zendaya, meeting her for the first time in her signature off-duty look: a hoodie and glasses and no make-up. "She struck me instantly as a quiet, powerful force," he said.

OVERLEAF Zendaya played the role of a young addict in *Euphoria* and her clothing, hair and make-up were all part of the narrative.

"I think Rue has a lot of really cool vintage pieces *that made me want to start getting* more vintage T-shirts *and things like that."*

ZENDAYA

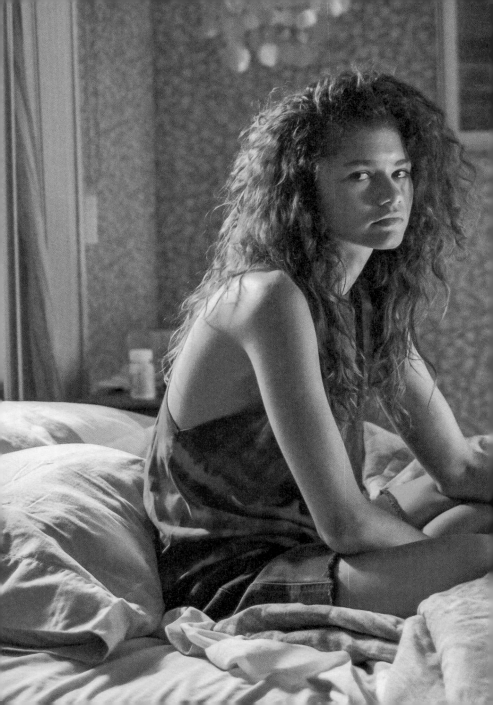

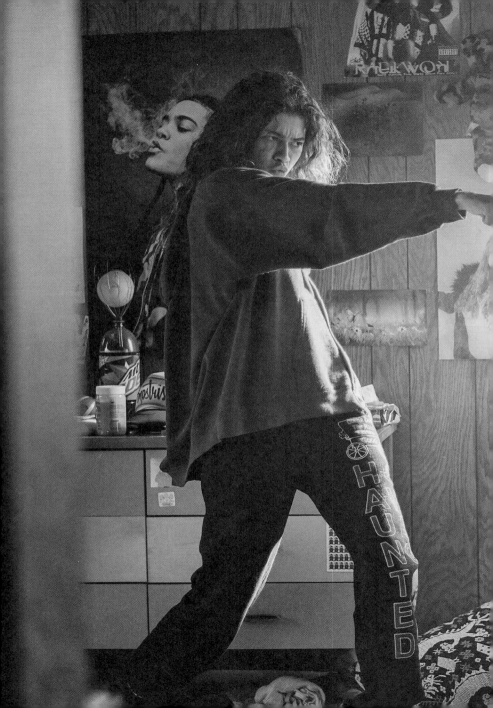

PREVIOUS The dark red hoodie Zendaya wore
throughout *Euphoria* became symbolic.

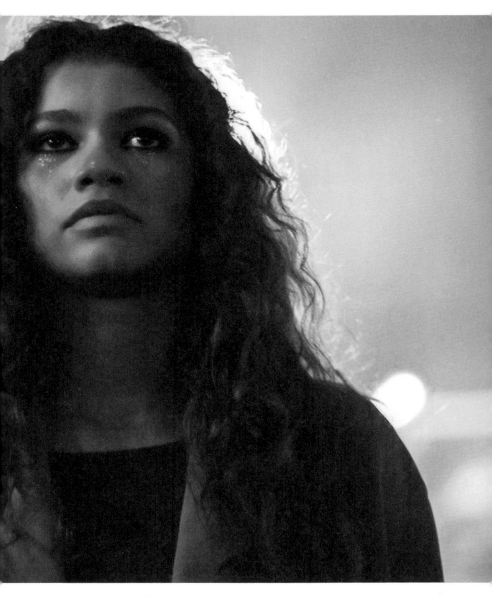

ABOVE The glitter tears Zendaya sported in *Euphoria*
became one of the most hyped beauty trends at the time.

"I've always been interested in things behind the camera. But Euphoria really grew my love for cinematography, *just watching Marcell Rév light things and make every frame gorgeous."*

ZENDAYA

In April 2023, Zendaya surprised everyone when she appeared on the stage at the Coachella festival as a surprise performer with the artist Labrinth. It was her first live musical performance in over seven years, since she released her debut album in 2013 but switched over to focusing on her acting career. Zendaya joined Labrinth on stage to sing two hits from the *Euphoria* soundtrack. She performed the songs 'All for Us' from the show's first season and 'I'm Tired' from its second season. Taking a cue from *Euphoria*'s Y2K-led style, she wore a light pink, satin-trimmed top over a white tank with a matching ruffled miniskirt and leather lace-up knee boots by Christian Louboutin. The look would have been perfectly at home in the halls of *Euphoria*, though it was more girly and less tomboy than something Zendaya's character Rue would have worn.

OVERLEAF When Zendaya staged a performance at Coachella in 2023, she wowed the crowd with a Y2K-inspired look.

The vintage look

One thing is clear: Zendaya is working on building up a wardrobe archive to be loved and cherished for years to come, particularly with her vintage pieces. "I want to reuse my clothes. I want to be able to wear that dress again when I'm 40 and be like, 'This old thing?' Really finding good vintage pieces that I want to invest my money in," she told British *Vogue*.

In recent years on the red carpet, she's made a point of wearing archive and vintage styles. At the 2023 NAACP Image Awards in Los Angeles, the 26-year-old *Euphoria* actress wore a silk black and green vintage Versace haute couture dress from its Spring/Summer 2002 collection. Later that evening, she wowed in another memorable look – this time, from Prada's Spring/Summer 1993 collection – which was comprised of white satin cut-out crop top, matching maxi skirt with cut-out details across the midriff and a white pair of leather heels. And of course, at the *Essence* Black Women In Hollywood event, she wore a green vintage YSL dress.

At the 2023 NAACP Image Awards, Zendaya wore a silk black and green vintage Versace haute couture dress from its Spring/Summer 2002 collection.

LEFT Here, Zendaya wears a custom Prada dress inspired by a vintage Prada look from the Spring/Summer 1993 collection.

OPPOSITE At the 2019 Emmys, wearing a vintage-inspired, custom one-shoulder asymmetric silk charmeuse gown by Vera Wang.

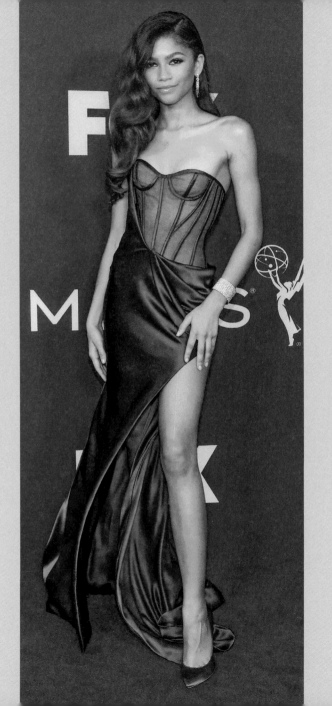

"*I want to* reuse *my clothes. I want to be able to wear that dress again when I'm 40 and be like,* 'This old thing?'"

ZENDAYA

Staying true to her forever inspiration of Cher, Zendaya has even leaned into vintage pieces from one of Cher's favourite designers. For the 2022 TIME 100 Gala in New York City, the 25-year-old *Euphoria* actor opted for a vintage Bob Mackie gown (a favourite designer of Cher). The gown was from the brand's fall 1998 collection and was constructed of velvet and silk panels in a luscious mix of green and black. She paid homage to an icon alongside another icon at the 2021 BET Awards: Zendaya posed with rapper Lil' Kim and wore vintage Versace reminiscent of the dress Beyoncé wore to the 2003 BET Awards. In fact, it was the exact same dress – albeit with a shorter skirt – worn by Beyoncé in 2003.

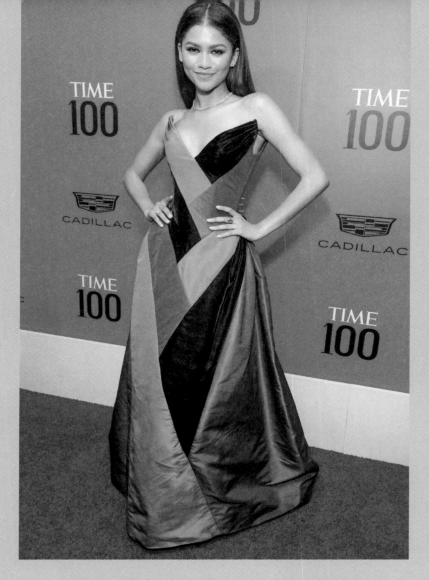

ABOVE Zendaya wore vintage Bob Mackie, a designer also favoured
by Cher, to the 2022 TIME100 Gala in New York City.

OPPOSITE At the 2021 BET Awards Zendaya poses with
rapper Lil' Kim and wears vintage Versace.

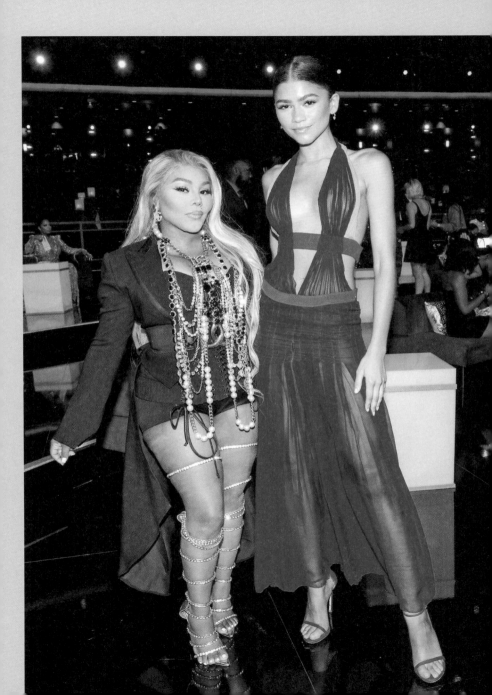

Law Roach forever

Law Roach continues to be pivotal to Zendaya's personal style. The two communicate in shorthand, sending each other screenshots through text messages for inspiration. She has said that every time they plan an outfit, they treat it like a film, with the actress standing in as protagonist with a storyline, background and everything else, obscuring the formerly shy little girl she used to be. She also describes trying new styles and different aesthetics as a way of actively discovering all the different sides of the woman she is. Law Roach was a big part of her winning the CFDA Award.

Shortly after Paris Fashion Week in spring 2023, Roach announced on Instagram that he would be retiring: "Retired," the caption read. "The politics, the lies, and false narratives finally got me." Shortly before he announced the news, rumours were swirling as Zendaya and Law Roach attended the Louis Vuitton show together in Paris and turned up late. When there was no place for him to sit next to Zendaya in the front row, she gestured to the second row. The video went viral. Both Zendaya and Law Roach chalked it up to a misunderstanding. As of 2023, Law Roach is retired, but working with Zendaya as her creative director. "I don't have to style Zendaya to be a part of her team and her creativity team, right?" he told *The Cut*. "So maybe if I choose, you know, not to be her stylist, I can still be her creative director and I can still, you know, manage a stylist or however I choose to do it."

Stylist Law Roach and Zendaya often have similar outfit aesthetics when they're together.

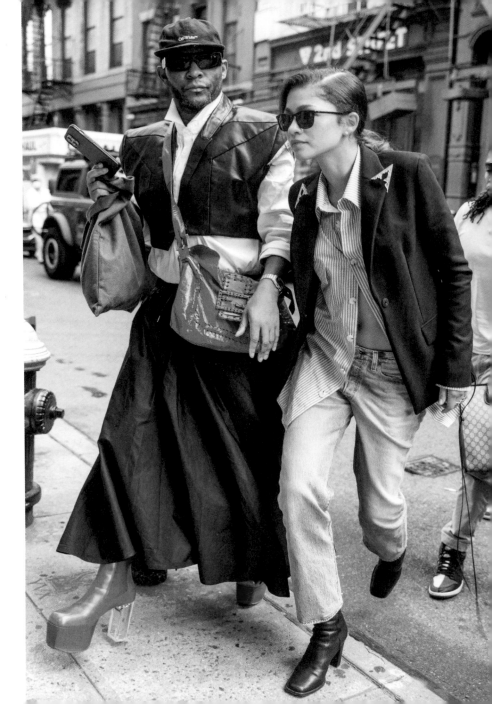

Generation Z(endaya)

Today, Zendaya has a clear aesthetic, marked by iconic looks that she's made her signatures. Take, for instance, the suit, or suiting materials, which she has been experimenting with and wearing since her very early days as a child star. Zendaya has always been into the idea of playing with gender-neutral and masculine elements. One of the best examples of this is when she appeared at the CinemaCon red carpet in Las Vegas in April 2023, wearing a deconstructed, backless halter vest from Louis Vuitton's fall 2023 collection, with matching structured trousers. Not only was it one of the starlet's first full Louis Vuitton outfits since joining the house as an ambassador, but she also walked the red carpet alongside her *Dune* co-star, Timothée Chalamet while wearing the outfit. Together, the dynamic duo gave off a futuristic vibe that so resonated with the aesthetics of the sci-fi themed film series.

Likewise, in June 2023, when Zendaya visited Rome for the opening of the Bulgari Hotel Roma, she chose a black tailored suit covered in little silver sparkles. The decision was actually a last-minute one because the original gown she planned to wear got lost in transit. But for the *Euphoria* star, it naturally fit in with her penchant for suits. "When in doubt…a @maisonvalentino suit :)" she told fans on Instagram.

Zendaya still prefers suiting elements in her ambassadorship at Louis Vuitton.

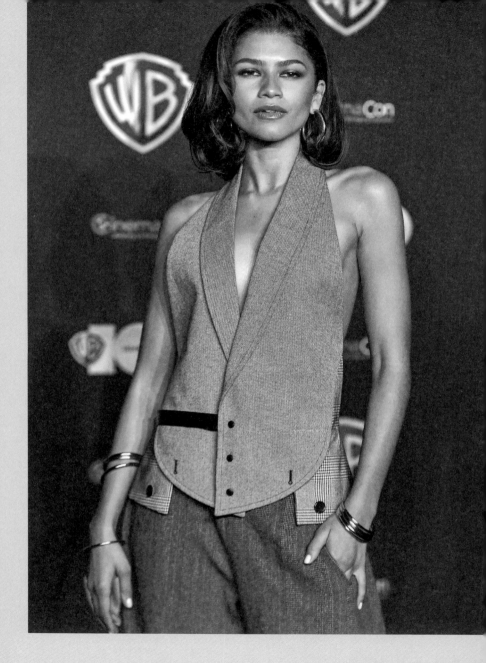

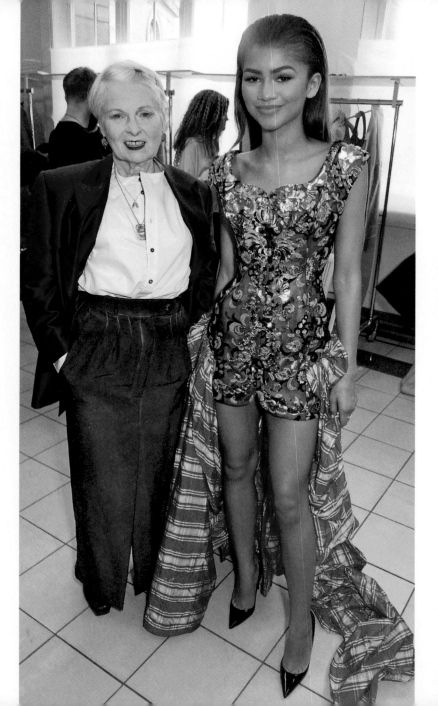

Even though Zendaya may serve as ambassador to some of the world's biggest fashion brands, she doesn't always let it define her personal style. At the tail end of Paris Fashion Week in 2023, she visited a restaurant wearing a highly structured, brown and white striped dress designed by Andreas Kronthaler for Vivienne Westwood. With its 1940s-style wide trousers and circular, cinched waist, it was the perfect fashion statement for a daring Zendaya. She's been a Vivienne Westwood fan since the beginning, wearing the brand all the way back to her earliest days in 2015. She has also been spotted shopping at the London store from time to time. Some of her other best suiting moments include the striking black option she wore to the *Vanity Fair* Oscars after-party and the grey blazer covered in a spray of glittering crystals shaped like a spiderweb, worn while attending a photocall for *Spider-Man: No Way Home* in London.

Zendaya's off-duty style goes back to her tomboyish ways when she was a very young child star. Whether or not she's been influenced by her character Rue, she loves a good T-shirt and jeans. But there are also a few other staples that she gravitates toward. Think: tailored blazers, structured button-down shirts, white tank tops and leather jackets. She also loves a good pair of sneakers, including high-top Converse, Nike Air Jordan 1s or PUMA Suedes. And if she's not wearing comfy footwear, she's usually in a slim, simple and elegant stiletto.

With the late designer Vivienne Westwood, who created some of Zendaya's most striking red carpet ensembles.

OPPOSITE The humble suit jacket will always be a part of Zendaya's wardrobe.

ABOVE Proving that sometimes something simple can be just as impactful, Zendaya still wears basics with an editorial edge.

But when it comes to analyzing the next generation of Zendaya's style, there's one clear winner in terms of daring, iconic moments. That would be when she wore a striking hot pink breastplate by Tom Ford to the 2020 Critics' Choice Awards. The dramatic piece, which was highly sculpted and resembled a wearable piece of art, was definitely one of the most striking style choices she had ever made. With its asymmetrical shape and cropped silhouette, it draped across her in metal and she paired it with a simple, silky matching maxi skirt. The look was plucked straight from Tom Ford's Spring/Summer 2020 runway show.

Ahead of the event, the Tom Ford team were tasked with moulding the breastplate to fit her frame perfectly, in person. "[The Tom Ford team] came to my house, and I stood topless in my living room while they had this machine that scanned my boobs," Zendaya told *Vogue*, of the look. In terms of design, this was one of the most dynamic pieces she had ever worn. While the outside was actually made of metal, the inside was lined in an absorbent fabric to ensure it was comfortable and also sweat-proof. "From a character perspective, I want to find things that will push me," she has said – and in this case the breastplate did just that. "As I get older, you know, I can't play a teenager for the rest of my life," she added.

Zendaya's Tom Ford breastplate is one of her most extreme looks of all time.

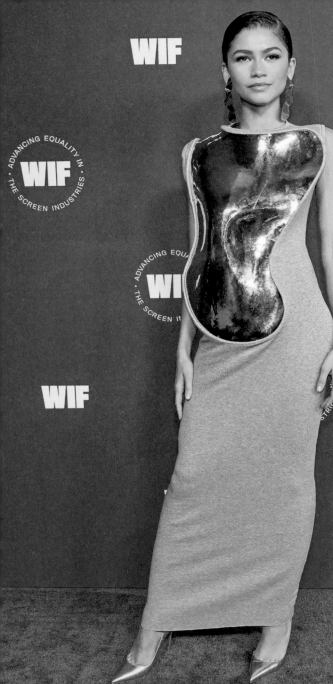

Almost a year later, Zendaya would recreate the metal breastplate look on an entirely different level, at the Women in Film Honors event in Los Angeles. She chose a grey Loewe dress which featured a gold, asymmetrical breastplate that matched her earrings. According to the brand, the brass plate was handcrafted in France by metal sculptors using unique soldering and hammer techniques.

Zendaya continues to experiment with her style. In a way, the breastplate moments were her version of a stunningly provocative fashion moment, done in a tasteful way that wasn't just for attention's sake. "Zendaya is such a good role model for young girls because she literally can and will wear anything," Law Roach once said. "A lot of girls her age go for 'naked' dresses, but we still haven't had a provocative moment. She knows who her core fans are – they're growing up with her." And as the world keeps watch, the one thing one can always come to expect from Zendaya is the unexpected. Truly, her style continues to keep the public and fashion fans guessing, leaving behind an endless wake of inspiration.

Here, Zendaya wears a golden Loewe breastplate dress.

"From a character perspective, I want to find things that will push me."

"As I get older, you know, I can't play a teenager for the rest of my life."

ZENDAYA

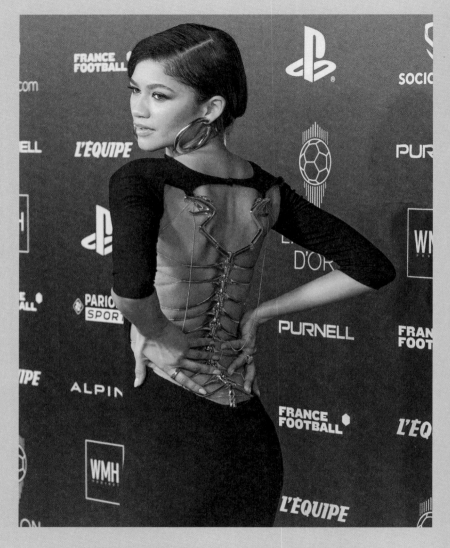

ABOVE It's all in the details – like this dress from Roberto Cavalli's autumn 2000 collection, which alluded to her Spider-Man role.

OPPOSITE Zendaya stuns in sculptural haute couture by Schiaparelli designed by Daniel Roseberry, outside the label's fashion show in Paris.

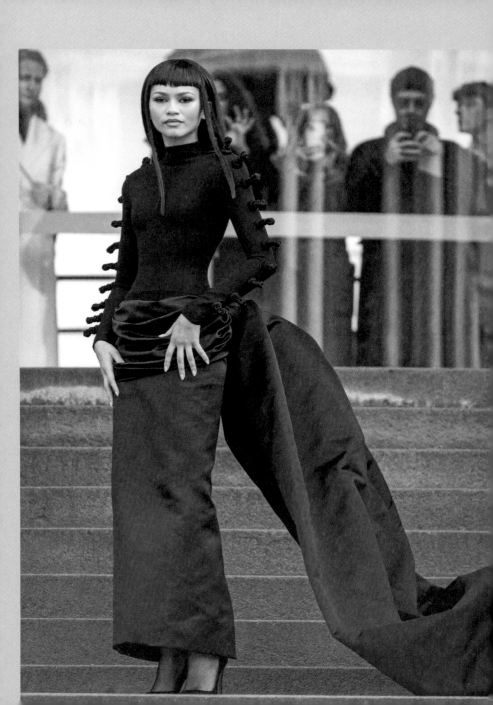

ℐndex

Credits

The publishers would like to thank the following sources for their kind permission to reproduce the pictures in this book.

Alamy: Abaca Press 142-143, 158-159, 218; / AFF 115, 175; /Evan Agostini/Invision 126; / Grzegorz Czapski 179; /Entertainment Pictures 116; /Everett Collection Inc. 40-41; / Image Press Agency 197; /JEP Celebrity Photos 105; / Landmark Media 86-87, 94-95, 96, 98-99, 182-183, 186-187, 188-189, 190-191; /Vianney Le Caer/ Invision/AP 163; / PictureLux/The Hollywood Archive 117; /Sipa US 93; /Brian TO/WENN. com 13; /WENN Rights Ltd 24-25, 58

Getty Images: Paul Archuleta/FilmMagic 42; /Don Arnold/WireImage 88; / Axelle/ Bauer-Griffin/FilmMagic 154, 210; /David M. Benett 208; /Allen Berezovsky/WireImage 33; /Alessio Botticelli/GC Images 49; / Frederick M. Brown 66-67; /Larry Busacca 107; /Stephen J. Cohen 28-29; / Noam Galai/ Getty Images for New York Magazine 111; / Earl Gibson III/Getty Images for ESSENCE 20; /Bruce Glikas/FilmMagic 34; /Gotham/ GC Images 205; /Steve Granitz/WireImage 15, 19, 65; /Frazer Harrison 76, 153, 213; /Frazer Harrison/AMA2013/FilmMagic 30; /Taylor Hill/FilmMagic 178; /Tibrina Hobson 36; / Keith Johnson/Bauer-Griffin/GC Images 39; / Stefanie Keenan/Getty Images for Women In Film 214; /Jon Kopaloff/FilmMagic 26, 32, 45, 52, 62; /Jeff Kravitz/BMA2015/FilmMagic 10; /Jeff Kravitz/FilmMagic for HBO 148; / Claudio Lavenia 219; /Jackson Lee/FilmMagic 108; / Jonathan Leibson/Getty Images for FIJI Water 70; /Jonathan Leibson/Getty Images for The Princess Grace Foundation-USA 46;

/David Livingston 48; /Michael Loccisano/ Getty Images for Coachella 194-195; /Kevin Mazur/Getty Images for Daya by Zendaya 53; /Kevin Mazur/WireImage 151; /Kevin Mazur/ Getty Images for TIME 202; /Jeffrey Mayer/ WireImage 31; /Jamie McCarthy/Getty Images for Harper's BAZAAR 136; /Jamie McCarthy/ Getty Images for Marc Jacobs 166; /Jamie McCarthy/Getty Images for Tiffany & Co. 90; / Emma McIntyre/Getty Images for ELLE 125; /Jason Merritt 56-57, 69, 73; /Neil Mockford/GC Images 82; /Papjuice/Bauer-Griffin/GC Images 60; /Chris Pizzello 147; / Bennett Raglin/WireImage 9; / Bennett Raglin/ Getty Images for BET 198, 203; /Jacopo Raule 169; /Jacopo Raule/Getty Images for Fendi 6; /Stefano Rellandini/AFP 161; /Alberto E. Rodriguez/Getty Images for CinemaCon 207; / Patricia Schlein/Star Max/GC Images 61; /John Shearer/Getty Images for Vanity Fair 119; / Randy Shropshire/Getty Images for ESSENCE 177; /Kristy Sparow 102; / Jeff Spicer/Getty Images for Sony 211; /Pierre Suu 77; /Karwai Tang/WireImage 81, 85, 101, 112-113; /Brendon Thorne 51; /Daniele Venturelli/Getty Images for Bulgari 171; /Angela Weiss/AFP 130-131; / Matt Winkelmeyer 199; /WWD 157; / WWD/ Penske Media 133; /Noel Vasquez 23

Kristen Bateman is a New York City-based writer, editor and creative consultant. She has authored five books and also writes for the *New York Times*, *Vogue*, *W* magazine, *Architectural Digest*, *Elle* and many other magazines. Her focus is on writing features about fashion history and trends beauty, culture and interiors. She also has her own jewellery brand, Dollchunk.